CHICAGO
BY THE
PINT

A CRAFT BEER HISTORY
OF THE WINDY CITY

Denese Neu

Charleston London

THE
History
PRESS

Published by The History Press
Charleston, SC 29403
www.historypress.net

Cover image: Inset image on front courtesy of the Library of Congress.

First published 2011

Manufactured in the United States

ISBN 978.1.60949.125.3

Library of Congress CIP data applied for.

Notice: The information in this book is true and complete to the best of our knowledge. It is offered without guarantee on the part of the author or The History Press. The author and The History Press disclaim all liability in connection with the use of this book.

CHICAGO

BY THE

PINT

To Dad—for sharing your love of history but not the gene that allows you to drink crappy beer.

Thanks to all the brewery folks, colleagues and friends who helped make this happen. But special thanks to Steve Mosqueda, for without your encouragement, I might never have pursued this connection between creativity and alcohol.

WARNING LABEL

Every beer bottle has a mandatory government warning label telling us about the risks of alcohol consumption. In both Illinois and Indiana, a blood alcohol concentration of 0.08 percent will get you arrested and result in a suspension of your license for six months. If you are new to the craft beer scene, drink with caution because the blood alcohol concentration charts are deceiving. One drink is defined as a twelve-ounce 4.2 percent beer; in the craft beer world, 5 percent is light, and some brews can surpass 10 percent alcohol content. When possible, take public transit—the CTA and Metra will get you to several of the breweries. For those who require driving, enjoy the visits, but be safe—for yourself, for the people who love you and for the lives of others.

Please read, drink and drive responsibly.

Contents

Introduction

A Pint-Sized History of Brewing in Chicago (and Some Rambling About Urban History)

This is a bar stool reader of historic vignettes. If you are looking for the history of Chicago's current breweries, you are in the wrong place. Using the local craft brewing industry as a gateway to history, the stories are designed to be read in about the same amount of time it takes to enjoy a pint or two. They are written with the idea that they will be read during a visit to the brewery or brewpub or, at the very least, while drinking one of the brewery's beers. Needless to say, not every brewery is featured, and only those that easily lent themselves to stories of local history were selected. As a relatively new and burgeoning craft beer scene, several breweries opened during the writing of this book. But as with Nelson Algren, my publisher finally stepped in and wrested the manuscript from my perpetual editing. Here's where I recommend that you grab a beer—preferably a locally brewed one.

I'm an urban social scientist. I like to explore places beyond the bricks and mortar, beyond the neatly organized museum exhibits and tours. In the early '90s, I discovered the relatively small but widely scattered world of brewpubs. Then, only a few hundred breweries existed in the United States, but within that decade, the number rose to about 1,500. Over the years, my old beer traveling hobby has worn thin—like my dad's hair. But I remain intrigued by old historic buildings that house breweries and the local stories behind their names. In fact, my many past adventures led to this concept book. While sampling the brews, I was (more often than not) left wanting for more historical detail beyond what was presented on the menu or the

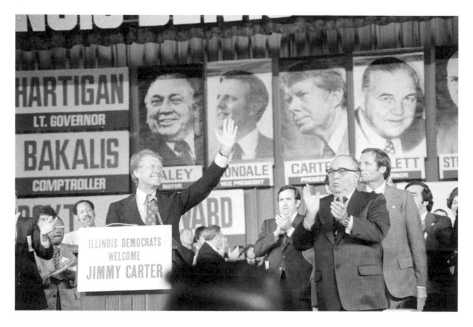

Richard M. Daley, who served as Chicago's mayor from 1955 to 1976, was one of the most powerful politicians of the twentieth century. Here he is shown with democratic presidential candidate Jimmy Carter, whose brother would release a small batch beer, Billy Beer, while he was in office. *Library of Congress.*

label. Having visited more than 300 breweries and brewpubs in more than a dozen countries, I can't tell you how many bar stools I've sat on wanting to know more about the back stories of the place. When I moved to Chicago in 2003, I was perplexed that only a few breweries existed within the city limits—a city with a population of 2.7 million people, yet one could count the breweries on one hand. Something was wrong here, especially given its history of brewing and the fact that the city is home to the Siebel Institute of Technology (a world-renowned brewing academy).

Something was indeed wrong, and that something's name was Mayor Daley. Like a modern-day Anti-Saloon League member, he had shut down neighborhood taverns across the city. And he made it hard to get a brewing license. In a city known for its hard-drinking journalists, one can only assume that he was maybe punishing the citizenry for Mike Royko's alcohol-fueled attacks on his father, the first Mayor Daley. The Chicago Way just wasn't good for locally crafted beer.

So what about beer? Well, long before there was Chicago, there was beer. Scholars believe that prehistoric people began making beer before they learned to make bread. There are beer recipes inscribed on tablets from

ancient Babylon. When Columbus arrived on the continent, he found the natives brewing with corn and sap. Colonists began brewing in 1587—it was so bad that they sent requests to England for beer shipments. And during the previous few hundred years, the Germans have been hard at work developing better brewing techniques. As the Germans immigrated to the New World, they brought their brewing knowledge and their drinking culture. As the fledgling new country expanded, the German immigrants opened breweries.

When Chicago was founded in 1833, it was merely a frontier village with a few hundred settlers who quaffed at two taverns that brewed their own beer. These small batch beers supplemented the infrequent shipments from the established East Coast breweries. A few years later, Chicago's first commercial brewery opened, and through a series of ownership changes, it became the Lill and Diversey Brewery in about 1841. It was also known as the Chicago Brewery. The brewery, along with many others, was destroyed in the Great Fire of 1871 and was never reopened. In the wake of the recovery, the city issued thousands of liquor licenses, and taverns were stocked by beer shipped in from nearby Milwaukee, as well as from the local breweries that survived or were rebuilt. In line with the rest of the nation, the number of Chicago breweries reached their peak during the 1880s and 1890s, and then the bigger breweries started buying up the smaller ones. By the 1970s, there were only forty-four breweries operating in the United States. But it wasn't corporatization that killed Chicago's brewing industry—it was prohibition.

Despite the fact that Chicago was a hotbed of bootlegging, and that some breweries continued to clandestinely operate, the city's brewing industry was not strong enough to gain a competitive foothold upon repeal. After sitting dormant for more than a decade, many breweries never reopened. Some had remained active by manufacturing other items, such as soda or near beer, and began brewing again. But corporatization and advances in industrial technology continued to put many of the independent breweries out of business. Old Chicago beer disappeared when Chicago's last brewery, Peter Hand, closed in 1978. It would be ten years before another beer was professionally brewed in the city, and it would be brewed at a small brewpub named Goose Island. It was 1988, a year when several new small breweries opened around the country. It was a pivotal year in the American brewing renaissance. It would take another twenty years before Chicago's brewing renaissance would truly arrive.

After Goose Island opened, a few others opened their doors. Some failed, and some managed to get a foothold, but mostly these were breweries outside of the city limits. With so few options, locals flocked to Goose Island

(that pun wasn't actually intended, but I'm sticking with it), and it became the ubiquitous local beer. In 2011, the demand had so greatly outgrown production capacity that Goose Island was sold to Anheuser-Busch. In this case, history has repeated itself only so much as capital infusion. With the growth of the craft beer industry, even the big brewers are getting into the game rather than switching production lines to their traditional American pilsners. While many Chicagoans lamented the sale, Goose Island continues to brew the beers that locals know. For the craft beer fans who refuse to purchase a product associated with *the big guys*, they now have plenty of options to choose from, and most of these options really only came about during the past few years. In fact, when Metropolitan Brewing opened in 2009, it was the first brewery to open in Chicago in six years. With its opening, it heralded a new era of Chicago brewing. Chicagoans have discovered great beer, and their demand is altering the city's landscape. New breweries continue open, and the new ones of last year are already expanding.

So, getting back to urban history, places are organic—they change with time and are shaped by people and events as much as by their natural and built environments. Each of these influences the others. The complexities of urban space and time are influenced by so many things that we easily disconnect history from our modern experience. But a city's soul is its history, and all too often the history goes unnoticed until suddenly the building disappears from the landscape or a new book is published. Mostly, we are so comfortable in our surroundings that we rush right by the historic markers that tell us *something important happened here.*

The library shelves are filled with the histories of Chicagoland—the histories that fill the streets and make it a unique place. Although a relatively new city, Chicago has a rich history, one that cannot be told by any one book or through any one lens. Chicago is a city of firsts and one of urban experimentation. Daniel Burnham's 1909 Plan of Chicago protected the lakefront to be enjoyed by all future generations, regardless of class or wealth. It created a legacy of how cities can shape themselves to balance the need of people and the demand of the powerful. But it is also a city where hundreds of thousands of poor immigrants and minorities struggled to survive in horrific housing and work conditions.

One cannot honestly talk about Chicago without exploring the juxtaposition between the good and bad elements. There are some who only see it as a city of prosperity, with a beautiful skyline and a rich cultural scene. Others experience it as a place of corruption, segregation and social ills. If you scale back to examine the confluence of time and urban patterns, you

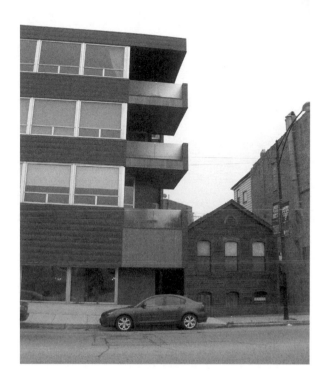

A nineteenth-century working-class house, with an entrance below street grade, sits next to a modern condo building. From the Loop's skyline to the neighborhoods, the layers of time and urban development can be seen. *Photo by Denese Neu.*

will see it like a person—one with scars and beauty and layers that may not always be obvious or easily understood.

Whether the topic is housing, crime, urban planning, arts or social culture, the city of Chicago is worthy of study. As for history, the books continue to be written as scholars dig through the evidence and ephemera. But history isn't relegated to the archives; it is very much alive, on the streets and bar stools. While researching this book, I often found myself so fully immersed in material that nary a word hit the page. Some of you may fault me for snubbing that bibliographic standard of scholarly work, but the stories that emerged were often not the ones for which I had initially embarked. I examined thousands of sources and let the material lead me. On more than one occasion, the vastness of detail made my head spin worse than three pints of Pete Crowley's brew down at Haymarket. If some of the facts are wrong, I take full responsibility for not researching back to primary sources. I won't blame it on the beer.

Cheers!

ARGUS BREWERY

Chicago, Illinois

THE BREWERY

Argus was opened in 2009 by the father-son team of Robert and Patrick Jensen. The brewery is located on the second floor of the former Joseph E. Schlitz distribution stables at 113th Street and Front Avenue and has a tasting room. Argus is a contract brewery and also sells beers under its own label. Its website contains links to places where you can enjoy or purchase its beers, as well as descriptions of its beers.

THE BAR STOOL STORY

The remnants of the heyday of Schlitz beer can be found throughout Chicago. The name remains on buildings and in barrooms as it was once the city's most popular brew. In fact, the Joseph Schlitz Brewing Company controlled so much of the market that the brewery developed two city blocks into what became known as Schlitz Row—a complex with company distribution buildings, worker housing and bars in the Kensington area. Argus Brewery, which opened in 2009, is housed along old Schlitz Row—just across the railroad tracks from the historic Pullman district.

Pullman was the model town built by the great industrialist George Pullman. One of thousands who came to Chicago to make his fortune, he was one of the few who succeeded. Born in 1831 as the third of thirteen children, his formal schooling ended with the fourth grade. He went to

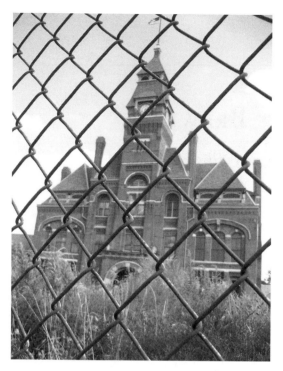

Little remains of the Pullman industrial complex as a result of abandonment and a 1998 fire. The Administration Building (pictured) was severely damaged and was subsequently restored, but it continues to sit empty. The town of Pullman is a designated city of Chicago, state of Illinois and national landmark district. *Photo by Denese Neu.*

work in his uncle's general store and then helped his father move buildings along the Erie Canal. In 1857, Chicago was in the process of regrading the streets to install a sewer system and improve drainage, and workers were needed. He answered a recruitment ad in the newspaper and departed Albion, New York, for Chicago. Taking advantage of the skills that he had learned while working for his father, he quickly found a Chicago business partner and set out to convince property owners that he was more than a worker—he was the man most qualified for the task.

Pullman, along with other contractors, was hired to lift entire blocks of commercial buildings. To accomplish this, his men would dig underneath the foundation, insert timbers and blocks and then set thousands of jacks into place. With six hundred laborers at the ready, Pullman blew a whistle and each man gave his screw one quarter turn. As the gap widened between building and land, pilings were inserted to reinforce the foundation. This was repeated until the building reached the specified height. All the while, shopping, tea and business carried on. This venture brought Pullman his first fortune. Only a few years after his arrival in Chicago, he departed for the Colorado Territory. It was the era of the gold rush, and the men seeking their fortunes needed to be fed and clothed. Investing his new capital in a retail business supporting the prospectors, he again increased his wealth.

Before heading west, Pullman developed a few rail car prototypes that would ultimately change travel and give him his place in history. He returned

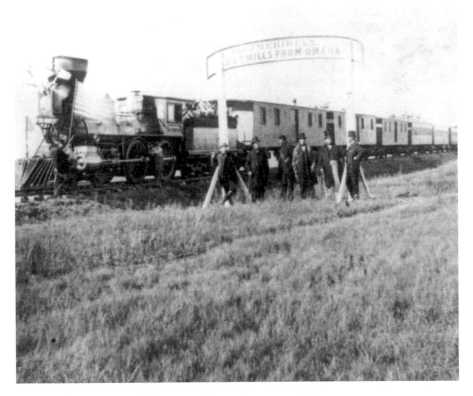

Before Pullman, rail cars were not built or equipped for passenger comfort. This image, mostly likely taken in the 1860s, shows the cars to be little more than wooden boxes that merely protected passengers from exterior elements during transport. *Library of Congress.*

to Chicago in 1863. The Civil War was raging, and the Union had passed the Inscription Act in March of that year. Declaring all men ages twenty to forty-five liable to be called for military service, Pullman found himself drafted. Taking advantage of his financial position, he hired a substitute soldier and then proceeded with his rail car business. Before Pullman, rail travel was miserable, with cars that had little more than uncushioned benches for sitting and uncurtained wooden shelves for sleeping. Trips could last days. With a vision to put a hotel on wheels, he began building the "Pullman Palace Car," which was marketed as luxury for the middle class. It improved the travel experience and increased the speed of the rail, as trains no longer had to stop for passenger meals and hygienic needs. In addition to sleeping cars, he built elegant dining cars, as well as cars that housed barbershops and grooming facilities. At the peak of rail travel, Pullman sleepers accommodated 100,000 persons per night. Potter Palmer, one of

Pullman's Chicago contemporaries and the developer of the Palmer House Hotel, was a mere innkeeper by comparison.

Pullman sought living improvements for his factory workers as well. To remove his workers from the industrial Chicago slums (and to separate them from the vice and labor organizing that he believed reduced production), he built a model town south of the city. Upon acquiring four thousand acres of swampland, he spent $5 million on developing and building a whole town to house the thousands of workers who manned the on-site factories and power plant. In the 1880s, his workers had indoor plumbing and gas lighting, paved streets and parks, while much of Chicago's working class lived in squalid conditions. His workers had access to goods and entertainment at the company-owned market, a pay-for-use library and a theater. He was generous by improving their living conditions, but he also made a 6 percent annual profit on the rents and limited the town to only one church. Despite the restrictions and control over the workers' lives, the town of Pullman drew international acclaim. More than ten thousand foreigners visited the town during the six months that Chicago's 1893 Columbia Exposition was open. The town was his utopian dream, but this dream did not include public speaking, independent newspapers or alcohol.

The Pullman workers included northern Europeans, as well as Polish, German and other eastern European ethnicities with strong cultures of beer. They couldn't get it in Pullman, but they could in nearby Kensington. Just across the railroad tracks, it was notorious for its saloons. In the late 1880s, there were at least four breweries lining the street along the tracks. Schlitz Row comprised two city blocks with taverns, beer gardens, stables and cheap boardinghouses.

Turn-of-the-century immigrant workers streamed out of the Pullman factories at quitting time, walked to the other side of the tracks and bellied up to these bars along Schlitz Row. The rooms were filled with smoke and exhausted workers speaking multiple languages. Throughout Chicago, the saloons gave the hundreds of thousands of laboring men respite from their harsh work conditions. But the saloons also generated social and domestic problems. Too many of the men would drink their wages and then come home to abuse their wives, while their children were left hungry and cold. For decades, women organized and fought for temperance laws as a solution. All the while, women also organized to fight for the right to vote. Of course, one of the most vehement opponents to women's suffrage was the liquor lobby. Unable to vote, these women asserted their power by joining forces with religious leaders. They won their fight for the passage of the Eighteenth

Amendment—the prohibition of alcohol production, transport and sales in the United States. With prohibition in effect, legal alcohol production and distribution on Schlitz Row came to a screeching halt.

Beginning in the 1970s, many of the row's original buildings met the wrecking ball. One architectural loss was a Schlitz tied house that had been identified as a potential historical landmark. Tied houses were taverns contracted with a brewery to exclusively sell its products. Common in pre-prohibition Chicago, the Joseph Schlitz Brewing Company was the most prolific, with the construction of at least fifty-seven tied houses from the 1890s to the early 1900s. Although many have disappeared from the city's landscape, the buildings can still be identified by architectural details. The brick colors and patterns form one unique characteristic, but mostly it is the concrete relief of the belted Schlitz globe insignia on the exterior of the building. In early 2011, two existing Schlitz tied houses were approved for Chicago landmark status, and seven more were under review by the city. Just a few doors down from Argus Brewery, an old Schlitz tied house sits abandoned and boarded up, awaiting protection of the city and a willing investor to restore it.

Today, some of the original Pullman and Schlitz Row buildings remain but sit abandoned or in various states of disrepair or rehabilitation. The Argus Brewery, housed in the former Schlitz stables, is easily identifiable, as the architects Frommann and Jebsen adorned it with sculpted terra-cotta horse heads protruding from the second story. Over the years, the building has also served other uses. It was a window factory, a boat storage facility and, according to an old squatter, a fire station, but local historians indicate that there is no validity to that claim. Today's owners honor the original use of the building by giving most of their beers names with a horse reference.

Once inside the brewery, it can be seen that many of the original architectural details remain, but the most notable feature is the old elevator used to transport the horses to their second-story stalls. It is also the central point for unusual happenings that many of the workers believe to be paranormal activity. In the era of Schlitz Row, it is likely that more than a few men lost their lives here. On-the-job injuries and deaths were common events, particularly in the breweries, where the men drank on the job as part of their compensation. Industry was largely unregulated, so there were no required safety precautions, interventions and oversight until the U.S. Department of Labor was formed in 1913. In fact, it wasn't until 1970 that the federal government finally obtained authority to set and enforce safety and health standards for most of the country's workers.

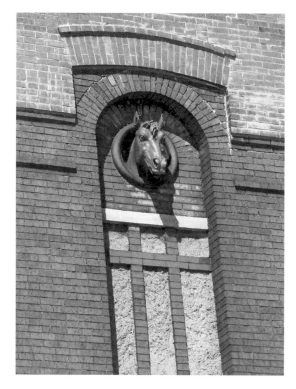

Terra-cotta horse heads adorn the Schlitz delivery stables that now house Argus Brewery. *Photo by Denese Neu.*

According to a few of the workers, the lights turn on and off, unusual drafts are felt and doors close by themselves. One incident left a brewer locked out of the building. Using the elevator to take the garbage out, he returned to find the elevator shaft doors closed and secured from inside. Yet when he had left only a few minutes earlier, he was alone in the building. The bi-fold doors require being closed in a particular order, and the lock requires being pushed up—both tasks that could not have happened without some manual manipulation. In order to return to the second-floor brewery, he had to return to the first floor, exit the building and reenter through the front door and stairwell. The elevator's mechanical room, accessible only by climbing a ladder to the roof, is so creepy that even the owner won't enter it alone. But he's perfectly comfortable in the tasting room, where visitors can once again enjoy some beer along old Schlitz Row.

CROWN BREWING

Crown Point, Indiana

THE BREWERY

Crown Brewing, opened in 2008, shares space with Carriage Court
Pizza. It is housed in a restored historical building that was once part of
the Lake County Jail, which was featured in the 2009 movie *Public Enemies*
starring Johnny Depp. Also in 2009, the award-winning brewmaster Steve
Mazylewski took the reins. In addition to the brewpub, its beers are available
at several other Indiana locations. These can be found on its website along
with descriptions of its beers.

THE BAR STOOL STORY

Today's Crown Brewing is not the first brewery by this name. However,
without much documented history, little is known about the original Crown
Brewing Company that also operated in Crown Point, Indiana. What is
known is that three Chicago businessmen filed papers to open the brewery
on May 17, 1895. They then proceeded to engage the Peter Hand Brewery
of Chicago in a beer price war. In area saloons, a nickel would get you a
glass of beer and a free lunch. Predominantly distributed along the route of
the old Erie Railroad that connected Crown Point to Chicago during that
era, the brewery owned at least one halfway house. In the era of slow and
arduous travel, the halfway house was where the weary traveler could stop
for a meal, a cheap bed and a bath before moving on. Unlike today's halfway

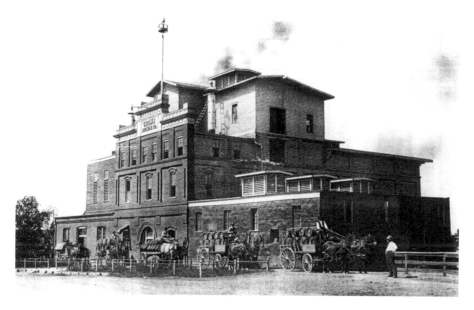

The original Crown Brewing Company in Crown Point, Indiana. This image, taken between 1895 and 1910, shows the Crown logo, which has been reproduced and tops the new brewery's smokestack. *Lake County Historical Museum.*

houses that serve and support recovering alcoholics and drug addicts as they reenter mainstream society, these halfway houses welcomed the drinker. Halfway between two points along the route, the brewery had a captive audience and no competition in its establishment.

In 1910, the brewery moved to what is now Calumet City. There, it operated under the name Great Lakes Brewing Company until prohibition forced its permanent closure ten years later. However, beer production in the area did not stop, as a series of northwestern Indiana illicit breweries were quickly built to supply the Torrio and Capone organizations in Chicago. The reason for relocation from Crown Point is unknown, but local historians speculate that it was prompted by unsanitary conditions created by the brewery draining the hops into the nearby waterway.

The new Crown Brewing sits across the courtyard and around the corner from the old Lake County Jail. The brewery itself is housed in what was the prison's boiler room and vehicle maintenance garage. This isn't just any old prison—it's where John Dillinger, Public Enemy No. 1, was held for the murder of Officer William O'Malley. During the first few years of the Great Depression, Dillinger and his gang robbed two dozen banks and plundered police arsenals throughout the Midwest. Feeling helpless amid the economic hardships and high unemployment, the downtrodden masses regularly cheered

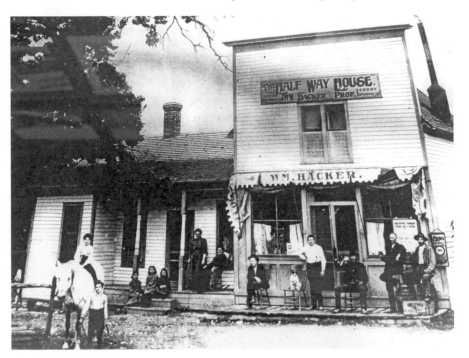

An undated photograph of the Half Way House. Commonly associated with breweries, this one was tied to Crown Brewing Company and was likely situated along the railroad linking Crown Point to Chicago. *Lake County Historical Museum.*

his image during the newsreels shown in the movie houses. They made heroes of gangsters who took what they wanted. Dillinger dominated the headlines, and his rumored antics entertained. He was said to wisecrack with the bank tellers, charm the ladies during the robbery and orchestrate exciting getaways. He was brazen with law enforcement and liked to brag to the wardens that he would escape. He did escape, more than once. The last time was from the Lake County Jail in Crown Point—a jail that was considered escape-proof.

Before John Dillinger was Public Enemy No. 1, he was just the son of a hardworking Indianapolis grocer and his wife. Born in 1903, he lost his mother only a few years later at the age of three. His father raised him in an atmosphere of disciplinary extremes that swung between harsh and repressive to generously permissive. By the time his father remarried, Dillinger was already on the path to trouble and resented his stepmother. At sixteen, he dropped out of school to work in a machine shop by day. By night, he was drinking, fighting and visiting prostitutes. During this period, his father moved the family away from the city in the hopes that rural life would be less corrupting. At twenty,

Dillinger joined the navy after some trouble with the law but then quickly went AWOL. He then married the sixteen-year-old Beryl Hovious.

Returning to Mooresville, Indiana, where his father had resettled the family, Dillinger committed the crime for which he would receive his first conviction. On September 6, 1924, he and a friend robbed and assaulted a man. Both were arrested. At the behest of his father, he pled guilty, but leniency wasn't in the cards. Sentenced to a maximum penalty of ten to twenty years in prison, he resented that his accomplice had gotten off easy. His friend had a criminal record and pled innocent and was released after only a few years. Adding insult, his wife divorced him on the ground of being a convicted felon. While serving his time at Indiana State Prison, he was housed among hardened criminals, and there he established the network for his future career in the bank robbing business.

The citizens of Mooresville were forgiving; 184 of them signed a petition for his early release as his stepmother lay dying. On May 22, 1933, he was paroled. She died before he arrived home. Less than three weeks later, he hit his first bank in Bluffton, Ohio. Later captured by Dayton police, he was held at the county jail in Lima. While awaiting trial, he escaped with eight other inmates. The timeline that follows is filled with bank robberies, violence and pursuit by federal law officers. Through it all, he managed to keep a girlfriend, Evelyn "Billie" Frechette, who later served two years in federal prison for harboring Dillinger after his escape from Crown Point.

Dillinger's downfall began on January 15, 1934, when he and his gang robbed the First National Bank in East Chicago, Indiana. Shots were exchanged, and Officer William O'Malley was fatally wounded. Dillinger, wearing a bulletproof vest stolen from a police arsenal, escaped unharmed. O'Malley was Dillinger's first kill, although he and his gang would eventually kill ten men and wound seven others. Following that robbery, Dillinger and his gang fled to Florida and then to Tucson, Arizona. He was captured after a fire destroyed their cover and firefighters recognized the men from pictures. Upon receiving news of the capture, Robert Estill, the Lake County prosecutor, quickly made plans to arraign him on charges of murder. Estill had higher political ambitions and determined that sending Dillinger to the electric chair would help his future campaigns. He personally escorted Dillinger to the ostensibly escape-proof jail in Crown Point. Unfortunately, he fell for Dillinger's charisma during the media frenzy, and a photograph of Estill with his arm around Dillinger destroyed his political career.

Dillinger didn't spend much time in Crown Point. On March 3, 1934, he seized opportunity and carried out a complicated escape. In the process, he

locked up thirty-three people, including the warden and a dozen deputies. In the vehicle maintenance garage, he stole and escaped in Sheriff Lillian Holley's brand new V-8 Ford. With a full tank of gas, he and his cellmate were off to Chicago. And that is where he made his mistake. By crossing state lines in a stolen vehicle, federal officers were now involved. Sheriff Holley, incensed and embarrassed, went on record stating that if she got Dillinger back she would shoot him with her own gun. Sheriff Holley, a woman handed a job she didn't want when her sheriff husband was killed in the line of duty, took the blame. Both officials and the press made an issue of her gender, stating that a woman had no business being sheriff. She was forty-two at the time and spent the next sixty years of her life ensuring that John Dillinger had no place in Crown Point. She refused interviews, and the townspeople respected her. During those years, the site of this notorious event was abandoned, and both the prison and sheriff's house fell into severe disrepair. Only since her death in 1994 have true efforts been undertaken to restore the jail and share the story with the visiting public.

The Federal Bureau of Investigation (FBI) saved Sheriff Holley the trouble of shooting Dillinger. Led by Melvin Purvis, agents ambushed him outside the Biograph Theater at 2650 Lincoln Avenue in Chicago on July 22. He was shot and declared dead at 10:50 p.m. Accompanying Anna Sage and his new girlfriend, Polly Hamilton, he had just finished watching *Manhattan Melodrama*, a popular and vicious gangster movie starring Clark Gable. Sage was the madam of a Gary, Indiana brothel and the manager of a basement saloon. Because of her profession, the United States government was trying to deport Hamilton as an undesirable alien. With federal agents desperately wanting

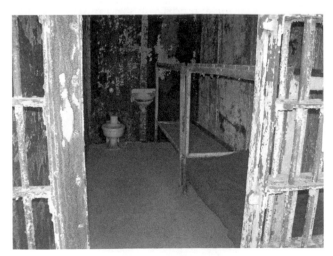

The jail cell that housed Dillinger until his escape. The jail was featured in the movie *Public Enemies* starring Johnny Depp, and efforts are underway to restore and preserve the facility. *Photo by Denese Neu with special permission granted by the Old Sheriff's House Foundation.*

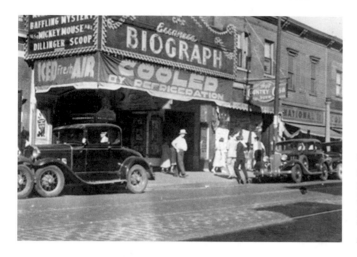

Chicago's Biograph as it appeared during the era of John Dillinger. Note the marquee advertising "Dillinger Scoop." *Library of Congress.*

Dillinger, she set him up in hopes of immunity. Despite giving Dillinger to the feds, she was still deported back to Romania where she died in 1947.

Word of Dillinger's death spread, and thousands queued up to see the body. Four death masks were cast, and one was presented to Herbert Hoover, head of the newly formed FBI. Even in death, his notoriety grew. The media pictures of the dead body fueled a rumor about Dillinger's unusually large male organ, but the large bulge under the sheet was merely his arm uplifted by rigor mortis. Some believe that it was not Dillinger who died that night but rather a stand-in. The conspiracy theory is fueled by an autopsy report that had discrepancies between the live Dillinger and the body. The report shows a man with a rheumatic heart condition and lacking Dillinger's scars; a man with brown rather than blue/gray eyes; and a man much shorter and heavier. The autopsy report also went missing for fifty years, but in the "City that Works" (one of Chicago's monikers), it had merely been misfiled in a forgotten brown paper bag.

A theory has been posited that a local man named Jimmy Lawrence was killed instead. A small-time criminal, he was known to visit the Biograph and spend time with Polly Hamilton. And it is said that he bore an uncanny resemblance to Dillinger, who had amateurish plastic surgery to change his appearance while a fugitive. It is also said that Jimmy Lawrence disappeared the night of the ambush. The theory is further fueled by letters mailed to the editor of the *Indianapolis Star* in 1963 by someone claiming to be Dillinger —one even included a picture of someone who looked like him, aged. For anyone needing an excuse to remain on the bar stool to ponder and debate history, conspiracy theories abound.

FLOSSMOOR STATION RESTAURANT AND BREWERY

Flossmoor, Illinois

THE BREWERY

Dean and Carl Armstrong opened Flossmoor Station in the 1990s. In 2006, it was named Best Small Brewpub at the Great American Beer Festival. Along with daily specials, its website lists its beer awards and provides a virtual brewery tour to educate people about the brewing process. With names like Zephyr, Station Master, Roundhouse, Chessie, Iron Horse and Pullman, its beers honor the heritage of the rails.

THE BAR STOOL STORY

Industrialization and pollution. Impoverished masses and illiterate workers. Substandard living conditions and filth. Along with great wealth and industrial innovation, these conditions defined Chicago. Industry and railroads built the city into an economic powerhouse, and with the promise of jobs, immigrants came in droves. The elite men who created the jobs wanted to escape the poor environmental conditions of industry. They were the industrialists, the powerful and wealthy, and they desired to be isolated and insulated from the pollution and filth that built their wealth. And it was the railroad that gave them passage out of the urban landscape. The very steam engines that choked the air also provided access to fresh air.

One of the largest railroad companies doing business in the area was the Illinois Central (IC). Chartered in 1851, the company made smart

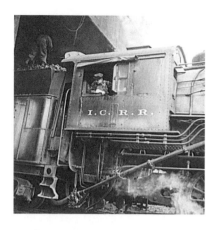

An Illinois Central Rail Road coal burning, steam-powered locomotive. While these trains helped build the economic strength of Chicago, they were also generators of the city's air pollution. *Library of Congress.*

strategic decisions from the beginning. While other railroads were developing from east to west, it headed south. The tracks initially connected to steamboats in Cairo, Illinois, to carry people and cargo south via the Ohio and Mississippi Rivers. But by the 1870s, it had laid or acquired tracks stretching from Chicago to New Orleans. It was so powerful that it converted 550 miles of track in one day. With this line, Chicago industry was connected to the rest of the world via the Port of New Orleans. These same tracks carried nearly 2 million black southerners during the years of the Great Migration (1910–40). Escaping the segregation of the South's Jim Crow laws, they came seeking jobs in the industrialized North and a better quality of life. Among these migrants were King Oliver, Louis Armstrong and Mahalia Jackson. They and many other talents carried the rich musical traditions of New Orleans and the Mississippi Delta to help transform Chicago into a world-renowned center of blues and jazz.

The IC was expanding its interstate routes, and as all industrialists did, its owners actively sought new ways to expand their business and wealth. The upcoming World's Fair and the land in the Flossmoor area created a significant opportunity. Not only was this event going to show the world that Chicago had rebuilt from the Great Fire, it was also going to draw visitors from around the world and help line the pockets of business leaders.

To meet the demand for transport to the fair's site, the Illinois Central put wooden coaches with small steam locomotives into service along one of its suburban lakefront lines. It also purchased land in 1891 in what would become known as Flossmoor. Originally an Indian settlement, only a few German farmers had established rural homesteads in the area, so the company easily acquired 160 acres at a good price. The intent was to strip it and sell the soil as fill for the fair's site on the swampy lands of the Hyde Park neighborhood. But the soil turned out to be unsuitable. Instead of writing it off as a loss, the railroad changed its profit strategy and later subdivided the land to be sold as home lots.

In 1899, the IC's landholding got a boost when some of the business elite from the Chicago Athletic Association decided to build a golf course in the

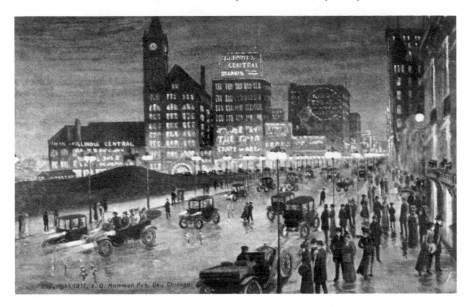

A 1911 postcard image of the Illinois Central headquarters on Chicago's Michigan Avenue. *ChicagoPostcardMuseum.org.*

area. (The association's historic building is located at 12 South Michigan Avenue, across from Millennium Park; it is now a hotel, but many of the original athletic club details remain). Their project was contingent upon the railroad's willingness to extend its suburban line and build a depot. It agreed, and a year later, the investors opened the Homewood Country Club. To traverse the two miles between the depot and the club, visitors would ride a tallyho (defined as a fast coach drawn by four horses). With virtually nothing in the area other than a train station and the club, the IC sponsored a naming contest to promote the area. Flossmoor, Scottish for "dew on the flowers" and "gently rolling countryside," was selected by the U.S. Post Office from a list of names presented by the railroad. The club would be renamed Flossmoor Country Club in 1914.

Other promotional tactics included excursion trains with a free lunch as an inducement to buy. This was so successful that four more country clubs were opened between 1901 and 1917. The area had become the playground of Chicago's elite, who built summer homes near the clubs. These members of Chicago's elite passed through Flossmoor's station, as did the golf greats who came to play in the tournaments. In fact, the Western Open (the equivalent of today's U.S. Open) took place at Homewood Country Club in 1906—the very year the current station was built. Many other top matches took place

during the following years, including the third annual Professional Golfers' Association (PGA) championship in 1920. These five historic country clubs remain open today.

The current building replaced the original 1904 depot that was conveniently lost to fire in 1906. Although the first depot was necessary to service the country club patrons and residents, it was not adequately designed for waiting passengers and was little more than a drop-off and pick-up point for people and post. It sat on the east side of the tracks, and passengers were forced to cross them on foot. The fire provided Illinois Central with an opportunity to correct these deficiencies and improve service to the area. The new station was designed as an appropriate venue to receive the wealthy Chicagoans coming to the area.

Another boost to the development plan came in 1919 when the Illinois Central announced the suburban lines' conversion from steam locomotives to electric trains. This cleaner form of travel wouldn't arrive until 1926, but the promise of cleaner transport drew new residents. The village's founding fathers added another protection when they purposefully prohibited industry within the town limits. With the possibility of no longer having to endure sooty rides to escape the city's pollution and factory smog, as well as a ban against industrial development, construction boomed. From 1924 through 1930, Flossmoor's population tripled to 808 full-time residents. Many were professors from nearby University of Chicago or executives of the IC. Although Flossmoor is barely mentioned in the six-hundred-page history of the Illinois Central Railroad by John F. Stoner, this community was home to IC leaders for decades. Among them was Wayne Johnston, who retired as IC president on November 30, 1967. His retirement didn't last long, for only a few days later, he died of a heart attack in his Flossmoor home.

The public library holds a few accounts of life in the village during the early years. One resident, the son of the local justice of the peace, recorded simple stories of that bygone era. He recalled the story of a group of young caddies walking from the Flossmoor Country Club to the train station. As they passed through an orchard, one of them took fruit on a dare. Nabbed by a local resident, he was escorted to the station and forced to wait until the justice of the peace returned from his day in Chicago. After several hours, the justice finally arrived. Impatient from the trip, he fined the caddy fifteen dollars—five dollars for each of three pears he had stolen. The storyteller estimated that amount to be the equivalent of pay for caddying thirty eighteen-hole rounds. Unable to pay the sum, the caddy agreed to turn over one dollar every Saturday at 3:00 p.m. On the fifteenth week, the justice

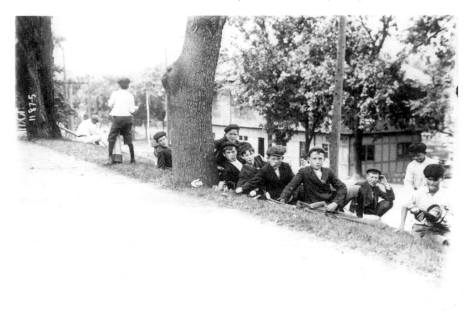

Young caddies in the 1920s. They were often working-class boys who traveled by train to the country club golf courses. *Library of Congress.*

called the boy back and returned the money. The lesson was more important than the punishment, and the lesson had been learned.

Since its construction, this station has played a significant, central role in Flossmoor. Without it, the village certainly wouldn't have developed in its current form or function. It was so important that the Civic Building was constructed directly across the street in 1929. Not only did the station serve as the impetus for the country clubs and protected residential area, but it also helped revitalize the old downtown area that is described by locals as having become a ghost town by the 1980s, a decade in which the railroads also experienced extraordinary decline.

In 1994, when Dean and Carolyn Armstrong purchased the depot, they didn't have a plan for what it would become. While the old Flossmoor commercial corridor languished, the train station had been reused as a small mall and was showing the toll of neglect. During a visit to Michigan, one of the states that led the craft brewing revolution, they ventured into a brewpub that was housed in a historic building. It was their first experience with craft beer, and they quickly knew it was perfect for their old station. But their plan to open a brewpub was met with resistance. Some old-time locals feared

that a drinking establishment in the middle of town would create problems and decrease Flossmoor's sense of community. Promising to create a vibrant community gathering place for all ages, the Armstrongs presented a detailed business plan to the community and the planning department. They were eventually given permission to proceed.

Walking into the station is a bit like stepping back in time. During the two-year restoration project, the owners were meticulous about preserving as much of the original building and features as possible. The historic ticket counter and old windows frame the hostess station. The bar area floor was removed and reinstalled brick by brick in order to replace the old sand bed

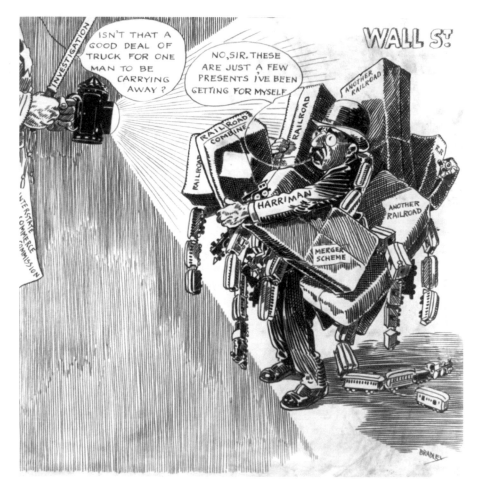

An editorial cartoon depicting greed and corporate corruption in the heyday of the railroads. *Library of Congress.*

that no longer passed code, but the original hardwood floors in the waiting area (now the dining room) could not be saved. As the brewery was designed, space became a problem. While exploring the crawl space under the building, workers discovered the existence of walls. These rooms had been filled by the debris of the rails: sand, dirt and coal. To remove it, the workers had to cut holes into the floor, and for three weeks they did nothing other than haul the rubbish out. The new basement provided the much-needed beer brewing space. The waiting room floor was replaced with oak planks. In their commitment to historic preservation, the workers used large chains to painstakingly hand-distress the new floor to blend into the structure.

It is likely that the railroad shoveled the debris into the basement because it was the cheapest method of disposal. During the years that the steam engine locomotives served Flossmoor, sanitation and environmental standards were low and industry was largely unregulated. Nearly every decision was about profit. But the history of the IC also shows a company that used its resources to help communities during hard times. During the Mississippi River floods of 1937, it lent its trains to displaced families, who took temporary shelter in the freight cars. And after the Category 5 hurricane Camille struck the Gulf Coast in 1969, it again used its north–south system to help those in the disaster zone. But nearly one hundred years before that, the Illinois Central, headquartered in Chicago, responded to its own community's disaster. Its own train was the first one in with relief supplies following the Great Chicago Fire in 1871.

GOOSE ISLAND CLYBOURN BREWPUB

Chicago, Illinois

THE BREWERY

This location is Chicago's oldest operating brewpub. Opened by the father-son team of John and Greg Hall in 1988, they currently have more than twenty drafts to choose from on a daily basis. This location offers tours, tastings and classes for people who want to learn more about various beer styles. It is also the monthly meeting place of the Chicago Beer Society, which was founded in 1977 and remains dedicated to the appreciation of beer.

THE BAR STOOL STORY

In 1873, the U.S. brewing industry reached its peak at 4,131 breweries. Most of them were small and primarily served their immediate communities. Over the next hundred years, corporatization took over, and the number of breweries shrank to fewer than 100. When Goose Island opened its first brewpub in 1988, it was one of only a few in the Midwest. In fact, that year saw 44 breweries open to reverse the trend of U.S. brewing history. In states where the laws allowed, small breweries were opening.

Like many of the other early craft breweries, Goose Island opened in an area of decline. These areas provided less community resistance, and just as importantly, they provided large spaces for cheap. With craft beer not yet part of the American palate, cheap locations were essential. When it moved into the building on Clybourn Avenue, the area (like many sections

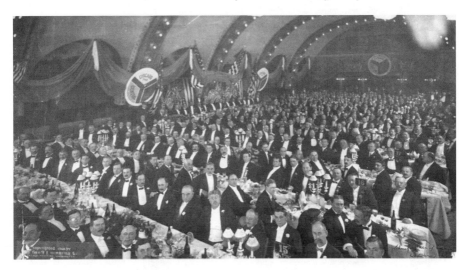

As the working class of Chicago labored in the factories and on the docks, the business leaders of Chicago worked to build the industrial strength of the city. This image of the Chicago Commercial Association shows the few hundred men who amassed wealth and power as business and civic leaders. The photo, dated October 7, 1905, was taken at the Chicago Auditorium, which now houses Roosevelt University. *Library of Congress.*

of Chicago) was filled with abandoned industrial buildings and crime. The area's reputation was so bad that, rather than risk their safety by exiting the cab, the delivery truck drivers would honk their arrival. As Chicagoans discovered their beer, their success grew. Drawing people back to the area, the brewpub served as an economic anchor for the revitalization of the Clybourn corridor while heralding in Chicago's small brewery renaissance.

The area of North and Clybourn was originally settled by industrial workers living near the factories along the North Branch of the Chicago River. During the decades of population growth that followed the Great Chicago Fire of 1871, the area increasingly drew immigrant workers. The factories, grain elevators and breweries offered jobs and with the working-class character came the taverns, beer halls and ethnic meeting rooms. Constructed in the late 1800s, the building that houses the Goose Island Clybourn Brewpub was originally used to manufacture brewery equipment; its last manifestation before abandonment was a Turtle Wax factory. For years, an old etched-glass Turtle Wax factory window hung above the bar. When it fell and shattered, nothing remained of that former tenant. But if you visit the lower-level meeting room, a few pieces of historic brewing equipment and Chicago breweriana are on display to pay homage to the building's original use and Chicago's brewing history.

On display in the brewpub, this historic brewing device dates from the early 1900s. *Photo by Denese Neu.*

Honker's Ale, one of Goose Island's widely distributed beers, is not named after the burley men who feared the area. Rather, it is simply a reference to the seasonal flocks of geese that pass through Chicago during their migrations. The Goose Island Brewpub was named after the actual Goose Island located just to the south of the brewery. Although the origin of the island's name is largely speculative, some Chicago scholars believe that it may have originated from a small clay island in the Chicago River. Home to geese and other birds, it was dredged away to clear the river for commerce. The modern Goose Island was artificially created in the 1850s under the direction of William B. Ogden (Chicago's first mayor from 1837 to 1838). Ogden, an owner of much of the land in the area and a major stockholder of the Chicago Land Company, acquired large tracts of land in 1853 to dredge a canal along the east side of the property. Dredged in 1857, the channel that created Goose Island expanded Chicago's water/land network and positioned the city for economic development.

About one and a half miles long, the channel added a waterfront for commercial activity. More importantly, it eliminated the need for river ships to travel the full distance of the river to the lake in order to turn around. Recognizing the value of linking rail and water transportation, Ogden ran the terminus of the first railroad built, straight to the river bank. Over the next several decades, the island became a mix of industry, shipyards, lumberyards, coal yards and grain elevators. Although Chicago was a city

of many industrial firsts, the grain elevator is not one of the inventions it can claim. But surrounded by the fertile prairie and aided by the ever growing railroad system, Chicago became central to the grain trade. Always innovating to increase profits, the city developed an elaborate grain elevator system, and the Chicago Board of Trade introduced a wheat grading system that allowed crops to be combined for both storage and sale. With the mechanized elevators eliminating the laborious work of hauling sacks, millions of bushels began arriving, were processed, sold and then dispatched across the country and the world. Along with cheap labor and rail transport, the grain industry also provided feed to Chicago's growing stockyard and packinghouse industry that also grew as a result of "Big Junction." Within only a few years of dredging the channel and laying tracks, Chicago was a site where more railroads met than anywhere in the United States or world.

In the shadows and noise of the island's industrialization, Irish squatters and working-class immigrants established a small residential community. Some believe that the name Goose Island was transported by the Irish squatters when they left the riverbank settlement near the original clay island and resettled on land that became part of the new island. Others posit that the new island's name originated from the flocks of geese kept by the island's shanty-town residents. The residents lived an existence that

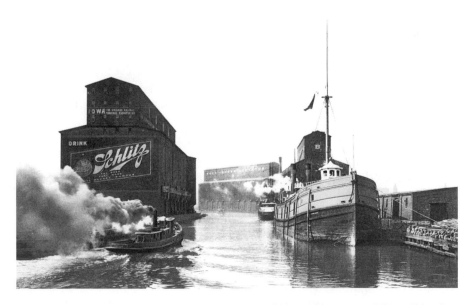

A historic image of the grain elevators that lined the Chicago River around Goose Island. Schlitz, along with other companies, used the structures as billboards to advertise to the men who worked in the vicinity.

fell between rural and urban, and their farm animals were fed with the slop from the local distilleries and breweries. Living in extreme poverty and under ethnic discrimination, anti-Irish depictions portrayed them as lazy, with too many rag-wearing children and farm animals kept in the house. Like many other immigrants from the general area, particularly Germans, these residents worked the docks and the yards on the island, receiving grain such as Wisconsin barley malt for the nearby breweries.

In that era, North Avenue was known as "German Broadway." Breweries were small and in abundance to serve those who lived nearby, and the industry was dominated by German brewers. In 1866, the twenty-one-year-old Dr. John Ewald Siebel joined Chicago's growing German population. But before immigrating, he earned his doctorate at the University of Berlin. Within a few years of arrival, he opened a chemical laboratory and led a scientific revolution for the brewing industry. His lab soon became a school for the brewing sciences and would eventually become the Siebel Institute of Technology. Still in existence today, Siebel is America's oldest brewing school. Always on the North Side, the institute moved its campus directly across the street from Goose Island's Clybourn Brewpub in 2008. Goose Island provides space for classes, and a small Siebel historical museum is also on-site, where one can learn about some of the technological advances led by Siebel.

With sixty operating breweries in the early 1900s, Chicago was one of the largest brewing centers in the United States. As with so many other industries, such as meatpacking and transportation, Chicago led innovation in brewing as well. The brewing industry grew into large plants with mechanized bottling lines. But when the Eighteenth Amendment (prohibition) passed, Chicago's role as a brewing capital ended. Some breweries continued to operate illegally, and some changed their product lines until repeal. But the Chicago brewing industry never regained its strength to compete with the national brands.

National beer brands from both Milwaukee and St. Louis took advantage of the railroads that Chicago built. Those cities' breweries, such as Pabst, Schlitz, Miller and Anheuser-Busch, would eventually dominate the domestic beer market as they purchased smaller breweries throughout the country. In the face of national competition, brewing in Chicago struggled. Eventually, all of the city's larger breweries shut down. As the decades passed, Chicago's manufacturing plants also closed as businesses relocated to places with fewer labor restrictions and lower pay scales. As manufacturers departed, swaths of urban abandonment were left in the wake. The Peter Hand Brewing

The Green Mill was a popular Uptown hangout of Al Capone's. The Fulton Street brewery playfully pays homage to area heritage with the brewery mill for its Green Line Pale Ale. *Photo by Denese Neu*

Company (near the Goose Island brewpub) ceased operations in 1978. With its closure, Chicago no longer had a single brewery. This was the landscape that left the area of North and Clybourn Avenue largely abandoned until Goose Island's arrival.

With the opening of this original brewpub, industrial brewing returned to the city. With palates becoming more sophisticated and locals developing a taste for locally produced beer, Goose Island's popularity grew. By 1995, it had become successful enough to support a production brewery and bottling plant. Now one of the largest regional breweries in the United States, Goose Island again outgrew its own production plant's capacity. In an ironic twist of fate, the brewery that helped reverse the mass production trend was purchased by Anheuser-Busch in 2011. Both Goose Island brewpubs (Clybourn and Wrigleyville) were not part of the deal and remain independent.

Goose Island Wrigleyville Brewpub

Chicago, Illinois

The Brewery

This brewpub, Goose Island's second location, opened in 1999. It's close to a major-league baseball field and is a great place to enjoy the combined American traditions of baseball and beer. It's also not a bad place to enjoy a beer during off-season.

The Bar Stool Story

In 1999, the Goose Island Beer Company purchased the unsuccessful Weeghman Park Brewery, which operated at this same location in Wrigleyville. The neighborhood takes its name from the iconic Wrigley Field—originally Weeghman Park—home of the legendary Chicago Cubs and rivals of the South Side Chicago White Sox. When it comes to baseball, being a true Chicagoan means pledging allegiance to one of these teams. Contrary to popular belief, the Chicago White Stockings team was not the origin of the White Sox. Rather, they were the origination of the Chicago Cubs. After a few name changes (Chicago Colts from 1890 to 1897 and then the Chicago Orphans from 1898 to 1901), the National League franchise became the Chicago Cubs in 1902. When the American League was formed and the new franchise came to town, they adopted the name abandoned by their crosstown opponents. Dating to 1900, the rivalry makes Chicago one of the great baseball cities.

A Craft Beer History of the Windy City

The first team playing under (or at least close to) modern rules formed in New York City in 1845 and quickly caught on in Chicago. With the opening of the Chicago Base Ball Club in 1858, it became an official form of recreation and competition. Considered to promote morality, reformists embraced it as an intervention to blood sport. Before baseball, Chicago sports were primarily saloon-based and were accompanied by gambling and drinking. Besides billiards, bare-fisted boxing and dogfighting were common forms of entertainment. And, of course, there was also the popular bear baiting, a medieval sport in which dogs tormented and mauled a bear chained to a spike. It was so popular in Europe that some communities had "bear gardens" right along with their beer gardens.

Injuries and such immorality defined the mid-nineteenth century "sporting man"—one who liked brothels and the racetrack as much as the bars. The new game of baseball challenged this ethos, and it helped push the blood sports to the fringes. Teaching teamwork and discipline, it was promoted by employers as an intervention to lost production time and labor unrest. Company-sponsored employee teams played against their industrial competitors, and baseball leagues were organized according to occupation. Competing in Chicago's parks and playgrounds, the sport was virtuous enough for family attendance—respectable sport was catching on. By the early 1900s, the definition of the "sporting man" had transitioned to a masculine ideal of physical prowess and self-discipline. Baseball had played a large role in this sociocultural shift, and its culture united the citizenry. The sport had exploded, and throughout the city, professional, semipro and amateur leagues engaged in the new national pastime.

Chicago's first professional team, the White Stockings, was founded in 1870, operated by William Hulbert, the man who would organize the National League. It was during these years that baseball's uneasy relationship with alcohol became a political point in the game. Hulbert was adamantly opposed to any association between baseball and alcohol, intending to draw well-heeled patrons to the stands. In fact, prior attempts to organize baseball had foundered in part due to the rowdy, drunken behavior of fans and players alike. In 1876, he banned both alcohol consumption and Sunday games from the league. One of the league's members, the Cincinnati Red Stockings, refused to abide and resulted in the team's expulsion after the 1880 season. Joining forces with other unrepresented teams to form the American Association, they secured financial backing from breweries and distilleries. Thereby, they became known as the Beer and Whiskey League. This league lasted until 1891, when the National

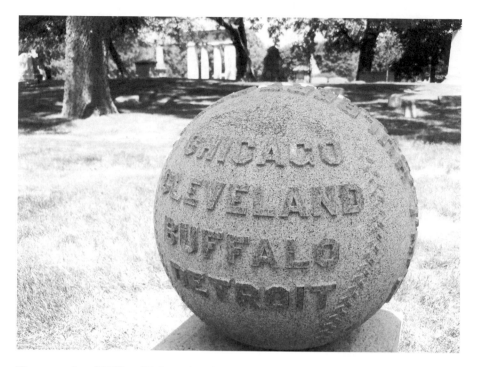

The grave site of William Hulbert, founder of the Cubs and the National League. Each side of the granite baseball lists four of the original eight NL teams. *Photo by Denese Neu.*

League adopted the "local option" of allowing teams to play on Sunday and serve alcohol within their ballparks.

Sadly, the sport that united strangers also institutionalized segregation and the Chicago White Stockings led the way. The manager/star player Cap Anson outright refused to let the team play against an African American pitcher. The year was 1887, and the policy of discrimination quickly spread throughout the league. With Jim Crow laws infiltrating sports and recreation, the flames of American racism spread. Thirty-two years after Anson's refusal, an African American teenager crossed an invisible barrier while swimming at a South Side beach. In retaliation for breaking the code of segregation, he was stoned and drowned by a white attacker. Riots erupted. The violence went on for seven days, and the tallies were horrific: fifteen white and twenty-three black persons were dead, more than five hundred people were injured and about one thousand black families lost their homes to white rioters' torches. Nearly one hundred years later, a strong pattern of residential segregation continues to exist in Chicago. But baseball's color

barrier was forever broken in 1947 when Jackie Robinson made his debut with the Brooklyn Dodgers.

At the time of the 1919 race riots, the Cubs were already playing on the North Side. But only a few years earlier, they still played ball in the wooden West Side Park—actually, they played at two parks of this same name. When Chicago's new fire codes were written after the Great Fire, they did not extend to the outdoors. On August 5, 1884, a fire broke out during a game. With fans trapped behind a wire fence, a quick-acting player used a bat to rip open the barricade, and fans streamed onto the field. Though one hundred were injured and half the stadium was burned, play resumed the next day. It would still be several years before the team relocated to the second West Side Park in 1893, the same year as Chicago's Columbian Exposition. In fact, they split their 1893 schedule with South Side Park in order to capitalize on the fair's attendance.

It was at the second West Side Park (also called West Side Grounds), not at Wrigley Field, where the Cubs spent their glory years. There they won the National League's first championship, followed by three more league pennants. There they had one of the most successful seasons in major-league history. There they won the 1906 National League Championship but lost the 1906 World Series to the White Sox. There the first crosstown matchup in series history was played. There they won the 1907 World Series against the Detroit Tigers. And there they won their last World Series Championship in 1908.

While the city rivalry between the National League Cubs and the American League White Sox raged, a new Chicago millionaire was eyeing the burgeoning baseball industry. A man of humble beginnings who had worked as a lunch counter waiter, he quickly learned the business and opened his own. Serving only cold sandwiches at one-armed school tables, his lunch counter empire grew to fifteen diners serving thousands of Chicagoans every day. When his 1911 bid for controlling interest of the St. Louis Cardinals was rejected, he helped launch the ill-fated Federal League. And with that move, Charles H. Weeghman (1874–1938) became the owner of the Chicago Whales.

To house his team, he leased vacant land from the Chicago Lutheran Theological Seminary. The lease stipulated that it could not be used for immoral or illegal purposes. Baseball, now symbolic of clean American values, was approved. The $250,000 ballpark, constructed of steel and concrete, was a masterpiece and quickly became known as one of the most spectacular. Built in 1914, Weeghman Park held sixteen thousand seats,

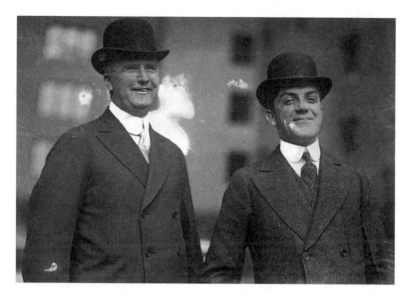

Weeghman posing with J.A. Gilmore, the president of the newly founded and short-lived Federal Baseball League. *Library of Congress.*

The early days of Wrigley Field. *Library of Congress.*

including two thousand ten-cent bleacher seats in right field. Fans who couldn't afford to attend the game stood on the nearby el platform that made the stadium easily accessible from downtown. And they watched from the residential rooftops—like the Cubs fans over at West Side Park. This new

stadium rivaled Comiskey Park, the new home of the American League's Chicago White Sox. Adding to the competition was the fact that both parks were designed by the same architect, Zachary Taylor Davis.

Tired of the deteriorating wooden West Side Park, Cubs fans flocked to Weeghman Park to watch the Whales. Challenging the American and National Leagues, the Federal League teams offered great sums of money to the AL and NL stars. Weeghman pursued Walter Johnson, the American League's top pitcher. He offered a $16,000 contract plus $10,000 signing bonus to lure him away from the Washington Senators. In an era when many players made only a few thousand dollars and held other jobs to earn a living, this was a princely sum. Ban Johnson, the threatened owner of the Senators, traveled to Chicago to meet and form an allegiance with White Sox owner Charles Comiskey. When Johnson departed, he did so with $10,000 of Comiskey's money. It was his contribution to counter Weeghman's offer—keeping Johnson in Washington was necessary to keep American League fans on the South Side. After a few more challenged recruiting rounds, and with the other leagues not respecting Federal League contracts, Weeghman declared war. Soon everyone was losing money, but the war quickly ended when the Federal League folded after its second season.

The Chicago Whales played well, finishing second and first during those two seasons. Although his league had failed, Weeghman was determined to stay in baseball. He and a partner purchased controlling interest in the Chicago Cubs, merged the Cubs with the Whales and played the consolidated team at his field. Nearly overnight, Weeghman's reputation was rewritten from villain to a sportsman who loved the game. And while his lease activity was moral, as stipulated by the seminary, some historical narratives suggest that his character was not.

Despite the city's segregation and the riots in 1919, his views on race were simply too much for many Chicagoans. On August 16, 1921, he sponsored the first statewide rally of the Ku Klux Klan. During the rally, two thousand new Klan members were initiated on his property. His business lost favor with the public, and his lunch counter chain was bankrupt by 1923. But even before this, the team had changed ownership, and Weeghman's name had been removed from baseball. Purchased by the chewing gum magnate William Wrigley Jr., the park was renamed Cubs Park in 1920. Six years later, it became known as Wrigley Field.

Regardless of his character, Weeghman was a revolutionary in the game of baseball. He was the first owner to allow fans to keep balls batted into the stands—a policy that would take years to be adopted across the major

leagues. And he was the man who initiated the practice of having behind-the-seats food stands within the park, most likely because it was quicker for customers to be served and increased sales. But that isn't to say that he introduced food and beverage to the ballpark experience. Beer was likely a ballgame consumable from the beginning, given the game's popularity with midwestern Germans. Some theorize that today's ubiquitous ballpark hot dog also stems from the German sausages that were served in the early years of the game.

Over the years, both stadiums added seating capacity. And both stadiums received the magic of Bill Veeck. When Veeck's father served as Cubs president, he planted the ivy that covers the Wrigley Field outfield wall. Veeck would go on to own several franchises before heading the group that purchased the White Sox in 1959. At Comiskey Park, he installed the "exploding scoreboard," with sound effects and fireworks. When the original Comiskey was demolished in 1991, the scoreboard was saved and transferred to the modern Comiskey II, later renamed U.S. Cellular Field. At Wrigley, the scoreboard was never modernized and continues to be changed by hand, a throwback to the baseball days of yore. While not the oldest baseball stadium—that honor belongs to Fenway in Boston—Wrigley is the only park still in existence that was home to a Federal League team. And despite its age, it serves as a model for cities building new urban parks, surrounded by a neighborhood rather than sprawling parking lots.

Sharing a city and a long history, the Cubs and the Sox continue to be deep-seated rivals. Men and women still watch and argue the games over pints of beer. They also argue the merits of the teams, debate fandom and use the teams as a dividing line of loyalties. Regardless of baseball stats, pennant wins or the number of years since winning the World Series, the Wrigleyville neighborhood trumps Bridgeport for fans seeking craft beer. Only Wrigleyville sports a brewpub—at least at the time that this book was being written.

HALF ACRE BEER COMPANY

Chicago, Illinois

THE BREWERY

Half Acre was started by friends Gabriel Magliano and Matthew Gallagher in 2006. After contract brewing to build their Chicago market, they began brewing at their own location in early 2009. Half Acre offers a regular line of beers, as well as annual releases and special brews. Its website provides more detail, features a blog and provides a list of where you can enjoy its beer.

THE BAR STOOL STORY

From the early days, the story of Chicago is shaped by flames. The Sauganash Hotel (with tavern), erected in 1831, was where the newly formed city elected its first trustees in 1833. It served as the new city's social hub until a fire forced its closure in 1851. But the flames that forever changed the city's future were those of the Great Chicago Fire, which happened only twenty years later. This incident was paramount to how modern Chicago is shaped today, and it led to new building codes that created a beautiful architectural heritage. The terra-cotta ornamentation adorning the historical façades was added not just for pure beautification but also to help slow flames. Limestone façades and brick replaced wood, and wooden water towers became part of the rooftop landscape. Essential for providing water pressure to fight fires, these structures once numbered in the thousands. Today only a few hundred remain, but their platforms have found a modern reuse as cellphone towers.

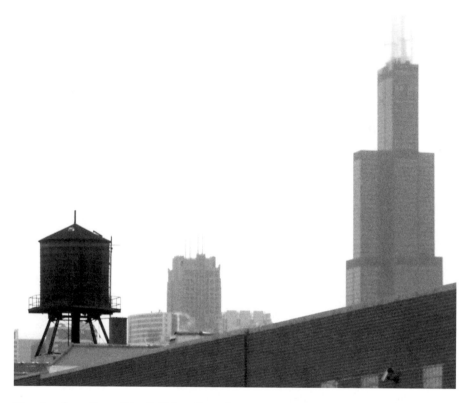

The view from Goose Island's Fulton Street brewery is a historic water tower in the foreground of the Willis (formerly Sears) Tower. *Photo by Denese Neu.*

An image of the iconic rooftop water tower is the original logo of the Half Acre Brewing Company. During the start-up years, it operated out of a business incubator while contracting with another brewery to establish itself in the Chicago market. A water tower was its view, and it was adopted as a motivational mascot of sorts. However, the brewery takes its name from a legend associated with the owner's home state of Delaware. As described during the interview, "Devil's Half Acre" was a small piece of land that hosted an illegal tavern and incognito burial ground where the violence regularly claimed the lives of canal workers and river men. When a man died, the owner buried him in an unmarked grave to avoid the authorities and being shut down. Supposedly, this was in the early 1800s, around the same time that Jean Baptiste Point du Sable, Chicago's first nonnative permanent settler, sold his property to John Kinzie.

A few more decades would pass before Chicago's population finally reached a few hundred. As with all new settlements, buildings were quickly

constructed of easily accessible materials. In Chicago, this was wood, and fire was always a risk—and this risk grew along with the population. As early as 1835, Chicago's trustees passed an ordinance requiring property owners to maintain water buckets in a conspicuous place, and everyone was required to serve as volunteer firefighters. Should a fire erupt, they were to grab their buckets and report directly to the emergency. As men lined up, the buckets were then passed from man to man and from water to flame. As a volunteer force, one didn't have to participate, but failure to show up for duty resulted in a hefty fine. These were the humble beginnings of what would eventually become the modern Chicago Fire Department, one of the largest and most respected firefighting forces in the world.

The first major fire occurred in 1839. During this incident, the Tremont House Hotel and seventeen other buildings were destroyed. In 1857, another large multi-building fire broke out. This one killed twenty-three civilians and firefighters. These disasters, along with the city's rapidly paced growth, led to the purchase of more firefighting equipment and the recruitment of more firefighters. Technological advances were also changing the techniques of firefighting, and the city soon had modern equipment. The arrival of a steam engine nicknamed "Long John" (in honor of Mayor "Long John" Wentworth) signaled the professionalization of firefighting in Chicago.

Systems designed to improve communication and shorten response times were also put into place. One advancement was the requirement that citizens help illuminate the streets for firefighters rushing to the blaze by placing a lighted candle in their window. By 1871, the year of the Great Fire,

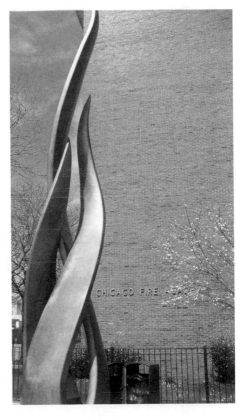

This sculpture, *Pillar of Fire* by Egon Wein, commemorates the event, but the actual spot of the fire's origin is marked by a plaque inside the Fire Academy. The site was designated a Chicago landmark in 1971. *Photo by Denese Neu.*

Chicago had 216 firemen. It was a strong but insufficient force to fight the average of two fires per day. And it was woefully inadequate to fight the blazes resulting from the fourteen-week drought during the summer and fall of 1871. By the first week of October, the city was virtually a tinderbox, and twenty fires were recorded in that week alone. On Sunday, October 8, only two fires were recorded. The second one started at about 9:00 p.m. when flames ignited in Mrs. O'Leary's barn. Located at the corner of Dekovan and Jefferson, then a poor Irish neighborhood, this is where the Great Chicago Fire began. Today, Chicago's Fire Academy sits on this very spot.

Fanned by strong winds, the fire swept toward the city's center, and the already exhausted firefighting force was quickly overwhelmed. Chicago, a fast-developing city built of mostly combustible material, went up in flames. As the flames spread northward, tens of thousands fled the city in desperation, some carrying only a handful of personal items that they could grab on their way out the door. Streets became clogged by carts led by panicking horses and terrified citizens. Between the raging flames and the chaotic exodus, an estimated three hundred lives were lost. After the fire, rumors spread that hundreds of hysterical women went into premature labor and that both mother and infant were trampled and incinerated by the flames.

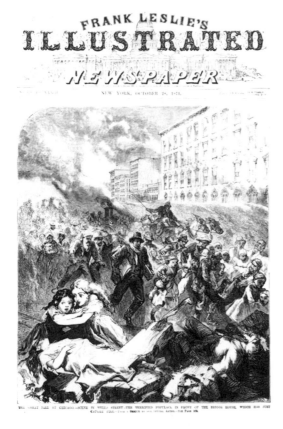

Depiction of the masses fleeing the Great Chicago Fire. At the forefront are frightened girls surrounded by a man and woman who appear as victims. *Library of Congress.*

For thirty-one hours, the city burned; it was only extinguished with the blessed arrival of rain. The "Burnt District" was four miles long and three quarters of a mile wide. About 100,000 Chicagoans were left

homeless, and eighteen thousand buildings were destroyed. Sixty insurance companies were forced into bankruptcy as a result of the claims. The entire business section of the city was destroyed, including six substantial railroad depots and the luxurious new Palmer House Hotel. Constructed by Palmer Potter as a wedding gift to his wife, it had opened only thirteen days earlier. Also among the losses were nineteen breweries, including Lill and Diversey, the largest brewery in Chicago and possibly west of the eastern seaboard.

Neighboring cities responded to the destruction. The railroads that had helped Chicago grow so quickly were now lifelines for the city. Ohio sent three engines from Cincinnati and one from Dayton. Other cities from around the nation and world sent money and donated supplies for emergency relief and rebuilding. Milwaukee sent beer. Partially motivated by goodwill, the gesture was a strategic business move to capture the large Chicago market. Amid the rebuilding, drinking establishments were booming. In fact, more than 2,200 saloon licenses were granted in the first eight months of 1872.

The strategy proved extremely successful for the Joseph Schlitz Brewing Company, for when the hundreds of barrels of beer arrived in the destroyed city, Schlitz became "the beer that made Milwaukee famous." It would further capitalize on this by adopting the phrase as its marketing slogan at the 1893 Chicago World's Fair, also known as the Columbian Exposition. During the fair's 179-day run, more than 27 million visitors from around the world came to Chicago. While companies like Schlitz plied their goods, the fair afforded Chicago the hard-fought opportunity to showcase itself. It had not only risen from the ashes, but it had also rebuilt itself as a world-class city.

The Schlitz exhibit at the 1893 World's Columbia Exposition in Chicago. The beer that made Milwaukee famous was advertised to the millions of visitors with an elaborate sculpture depicting its logo and then some. *Library of Congress.*

Daniel Burnham, the architect who oversaw the construction of the fair's site, went on to design the Plan of Chicago in 1909. Although many of his recommendations were not implemented, the Burnham Plan is still recognized as one of the most significant works in modern urban planning. This work, which he accomplished in concert with civic leaders and the business elite, became the blueprint to transforming metropolitan Chicago into a healthier, more efficient place. Not so ironically, the chairman of the Chicago Plan Commission was Charles Wacker, the same man who had served as director of the 1893 Columbian Exposition. Ironically, Wacker earned his position of power and wealth as a Chicago brewer.

Many attribute Chicago's lakefront parks solely to the Burnham Plan; however, this is not entirely accurate. While Burnham did draft schemes for a beautified lakefront and proclaimed that the lakefront belonged to the people, the city had already designated parkland long before Burnham's Plan. In fact, Lincoln Park was designated in 1865, named in honor of the recently assassinated president. But before it was a park, this land had served the city as a cemetery since the 1840s, and it posed public health problems. It also consumed valuable land in the fast-growing city that needed public space. At the time of the Great Fire, the cemetery along the lakefront was being excavated to create Lincoln Park. In the aftermath, some of the newly homeless took up temporary residence in the emptied graves. As for the fire debris, it was used to help build a larger lakefront and now serves as the foundation of some of the priciest real estate in the city.

The actual cause of the fire was never determined, but the myth that O'Leary's cow was the culprit remains alive today with the old child folk song:

Late one night
When we were all in bed
Old Mother Leary
Left a lantern in the shed

And when the cow kicked it over,
She winked her eye and said,
"There'll be a hot time
In the old town, tonight."

As for the falsely accused cow, the Chicago City Council officially absolved it of any wrongdoing in 1997.

Hamburger Mary's

Chicago, Illinois

The Brewery

Hamburger Mary's is a franchise with a home brewing owner. The hobby led to an expansion plan to offer beer brewed on-site in the Rec Room, a popular sports bar next to the restaurant. The location also features Mary's Attic, an upstairs entertainment venue for dance, live music and theater.

The Bar Stool Story

Hamburger Mary's brewpub is located in Chicago's Andersonville neighborhood, a quintessential urban village listed on the National Register of Historic Places. With 116 properties of historical significance, the community continues to show the vestiges of its Scandinavian heritage. Among these is the 1913 Swedish American Bank building that houses Hamburger Mary's. A designated Chicago landmark, its exterior is covered with distinctive white terra-cotta ornamentation. Above the second-story window is a notable keystone—the long-forgotten Chicago municipal device. The "Y" symbol, designed to represent the city during the 1893 World's Columbian Exposition, is rarely noticed, but it is found on municipal buildings and structures throughout Chicago. It represents the three branches of the Chicago River that come together at Wolf Point. It's the spot where fur trader and farmer Jean Baptiste Pointe du Sable built the first nonnative settlement in the area and claimed his fame as the founder of Chicago in the 1770s.

A bridge predominantly displaying Chicago's municipal device. The Y (sometimes inverted as on this bridge) is prevalent throughout the city's architecture and is an integral part of the Chicago Public Library's logo. *Photo by Denese Neu.*

The Swedes began arriving in 1846. A significant number were members of the religious Jansonite sect following their leader, Eric Janson. Claiming to be a true prophet, he challenged the teachings of the Lutheran Church. After several negative encounters with authorities, he condemned his homeland to eternal damnation and then departed for the United States. An estimated 1,200 to 1,500 Swedes followed him across the Atlantic to live in his central Illinois collective religious colony that came to be called Bishop Hill. Short-lived, it dissolved in 1861. Some of Janson's followers could not endure the full journey. Stopping along the Chicago River, they built a squatters' camp that grew into a small Swedish settlement. In 1848, there were only forty Swedes in Chicago, but the camp was already known as Swede Town.

As Jansonites wrote home about the fertile agricultural lands of the Illinois prairie, more Swedish immigrants came. By 1860, Chicago's Swedish population grew to 816; ten years later, 6,154 Swedes were living in the area. They farmed, helped build the canals to ease travel and transport and worked as skilled tradesmen. With reputations for cleanliness and strong work ethics, many of the men found factory jobs, and women easily secured domestic positions in Chicago's wealthy homes. The promise of prosperity was so strong that single women composed one-third of the Swedish immigrants. Their letters home described their earnings and comfort. With the promise of wages of four dollars per week plus room and board, the migration continued, and the area's Swedish population exploded. By 1900, Chicago had the largest number of Swedes in America and the second-largest number of Swedes in any city in the world. Only Stockholm, Sweden's capital, surpassed Chicago.

Out on the prairie, the Swedes established themselves in agriculture. By the mid-1850s, the area now known as Andersonville, was largely composed of orchards, a cemetery and a nursery. It is believed that the neighborhood's name was drawn from the Andersenville School, which also served as the community center. Erected in 1855 and demolished in about 1925, it stood at what is now the southwestern corner of Foster and Clark and may have been forgotten had a plaque not been placed on the building that replaced it. This was the spot where community leaders organized Lake View Township in 1857 and where the decision to incorporate with the city of Chicago was made.

Historians still have not determined for whom the school, and thus the community, is named. One theory is that it is named after Paul Andersen, a Norwegian minister who lived at Clark and Foster. The other theory is that it honors John Anderson, a Swedish farmer and early settler. But neither of these men would leave a mark on the Chicago landscape quite like Swedish-born Pehr Peterson. Settling west of Anderson's farm, he purchased five hundred acres of land and started the Rosehill Nursery in 1856. His innovative techniques for transplanting large trees won him contracts to supply much of the nursery stock for many of Chicago's parks and the grounds of the World's Columbian Exposition. By 1900, his business had also supplied most of the mature trees that line present-day Chicago streets. His contributions to Chicago were so extraordinary that he was knighted by the prince of Sweden; Chicago named a street and a park after him.

In the wake of the Great Fire of 1871, the city's geography shifted. The Scandinavians (along with Germans) suffered the greatest number of

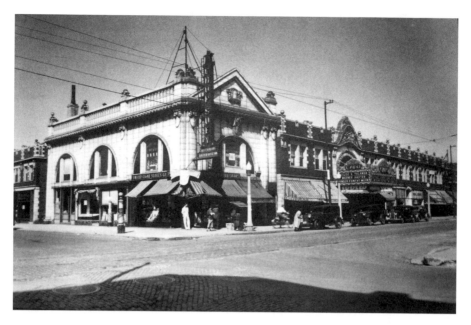

Clark Street in Andersonville, circa 1934. With the exception of windows, awnings and signs, little has changed in the block that houses the brewpub. *Edgewater Historical Society.*

fatalities in the fire, and the wooden homes preferred by the Swedes were afterward outlawed within Chicago's city limits. Rather than adapt to the new building codes, they migrated north, mostly to the area of Lake View. Over the next few decades, the northern migration continued. It wasn't until after 1905 that meaningful development occurred in Andersonville. However, after 1905, the area began to prosper, so much so that by the 1910s, it boasted more than one bank. Among the banks was the Swedish American Bank. Beyond the architectural detail, very little is known about the bank's actual operational history. By the 1930s, the Swedish American Bank building housed a cigar shop on the ground floor, with a Chop Suey restaurant above it.

Like many urban neighborhoods, the area continued to decline after the Depression. With the economic prosperity of World War II, better industrial jobs supported car ownership, which provided the option to not live near jobs or public transit. Throughout the country, the middle class flocked to the newly built suburbs, where they traded the cramped, old housing for modern amenities and lawns. The spaces they left often remained vacant or were filled by new immigrants or low-income families who joined the aging residents who stayed behind.

By 1963, Andersonville was just another aged urban neighborhood. But many of the traditional Swedish businesses remained open and helped anchor the community. In 1964, the name "Andersonville" was rededicated with the help of the first Mayor Daley and the governor. With fanfare to restore a sense of community pride, the Swedish heritage served to promote the commercial district businesses. But even into the 1980s, banks refused commercial financing due to the area's high investment risk. Now one of the most popular Chicago neighborhoods, a 2004 economic report launched Andersonville into the global urban planning spotlight. It is now recognized as a model for historic neighborhood revitalization through locally owned small businesses, including Hamburger Mary's. While it doesn't tap the neighborhood's local heritage, it does pay homage to Chicago's notorious Prohibition era activity with its Gangster Ale.

In 1920, the production and distribution of alcohol was driven underground, both literally and figuratively. Until the Twenty-first Amendment repealed the ban on December 5, 1933, alcohol remained illegal. But although it was illegal to manufacture, transport and sell alcohol, consumption remained legal during those years—and people were thirsty. Almost immediately, covert drinking establishments opened. Gangsters, like Chicago's Al Capone, happily stepped in to ensure that they were well stocked.

Like the quality of the booze, the quality of the establishments ran the gamut. Speakeasies were higher-class establishments, often offering food and live entertainment. It is believed that the name derives from patrons being asked to "speak easy" to help avoid drawing attention to the illegal alcohol sales. Blind pigs, on the other hand, were lower-class joints for the poor and working class. To circumvent the law, they charged a small fee to view an animal, such as a pig. With each paid viewing, patrons would receive a complimentary beverage. Andersonville was home to at least one blind pig and a speakeasy—and today, both buildings still house drinking establishments.

With the demand side firmly in place, the bootlegging industry boomed. Named after the practice of hiding flasks of liquor inside boots, it transitioned from mostly independent, small operations to a nationally organized network. But to reach that point, bloody gang wars were fought on the streets. With about five hundred men killed during these battles for market control, Chicago became the murder capital of the United States. Slowly, Capone picked off every other gang rival to establish his territory and become top boss.

One of the bloodiest incidents took place on February 14, 1929. Named the St. Valentine's Day Massacre, the murders were carried out in George

The Rosehill Cemetery grave site of Reinhart Schwimmer, the gangster groupie slaughtered during the Valentine's Day Massacre. *Photo by Denese Neu.*

"Bugs" Moran's warehouse at 2122 North Clark Street (demolished in 1967). Five gang members, plus two men who enjoyed the thrill of hanging out with gangsters, died in the attack. One of the men was young optician, Reinhart Schwimmer. Buried at nearby Rosehill Cemetery, he rests among more than a dozen Chicago mayors, several prominent Chicagoans such as Oscar Mayer, four Illinois governors and twelve Union Civil War generals.

All fingers pointed to Capone as the culprit behind the violent attack. Although it failed to get Moran himself, it succeeded in Capone winning full control of North Side alcohol distribution. The massacre also provoked law enforcement to step up its efforts to put an end to the violence. The mob responded. Three months after the attack, mafia leaders from the Midwest and East Coast gathered for a meeting in Atlantic City. There they solidified their networks to become a national organization with a system of arbitration aimed at reducing the bloodshed. It was 1929, just five and a half months before the stock market crashed and sent the country into economic collapse.

Al Capone reportedly liked to joke that he was blamed for everything from boys falling off tricycles to people stubbing their toes. But regarding Black Tuesday (October 29, the day of the stock market crash), he went on record denying any responsibility. Without federal protection of bank deposits, millions of American dollars literally disappeared when the banks closed due to the sudden lack of capital. The wealthy were wiped out, and the working class lost their modest life savings. Countless homes went into foreclosure, and unemployment eventually hit 25 percent. Fueled by the social and economic conditions of the time, respect for authority was decreasing among the general public.

Just a few doors down from Hamburger Mary's is the historic Calo Theater building. There, neighborhood residents took refuge from the hardships of the Great Depression by watching the wildly popular gangster movies and cheered for the bad guys. Fearful of social erosion, the American Catholic Bishops called for a boycott of Hollywood's gangster movies because they promoted violence and immorality. In 1934, the International Association of Chiefs of Police joined the protest. The pressure was on. Soon after, Hollywood filmmakers agreed to enforce the Motion Picture Production Code, the system that would be used to censor movies until 1968. With violence no longer allowed on the big screen, stars such as James Cagney switched to the good side. Cagney had become a star in *The Public Enemy* with his portrayal of a gangster based on a few of Capone's rivals. Now he was starring in movies such as *G-Men*, which glorified the government's fight against organized crime.

Al Capone wasn't convicted on bootlegging or murder charges—the G-Men got him for tax evasion. Sentenced to prison in 1931, he served eight years at Alcatraz, where he deteriorated from the lack of treatment for syphilis. He spent his final years at his Florida estate, and by the time of his death in 1947, the mastermind of gangland had degenerated to the functioning level of a twelve-year-old child. There is no public record of him ever returning to Chicago, but the gangland legacy maintains a presence through such things as Gangster Ale.

HAYMARKET PUB AND BREWERY

Chicago, Illinois

THE BREWERY

The Haymarket Pub and Brewery is co-owned by John Neurater and Pete Crowley, a brewer who has won more than fifty local, national and international awards. Opened on Christmas Eve 2010, their Angry Birds won a Gold Medal at the 2011 Great American Beer Festival. It is one of the rotational beers featured alongside guest taps. The back bar is home to the Drinking and Writing Theater, where audiences can enjoy performances that explore the connection between alcohol and creativity. When live theater is not featured, it's a great space for watching the games.

THE BAR STOOL STORY

In the first days of May 1886, the eight-hour workday movement gathered steam. Nationwide, an estimated 300,000 strikers rose en masse. In Chicago, more than 35,000 skilled and unskilled laborers walked off their jobs. The city was at the epicenter of the battle between the working class and the great industrialists who employed them and got rich from their labor. Led by organizers from the anarchist International Working People's Association, workers attended meetings and marched from workplace to workplace. Urging others to join them, they successfully closed down factories, shops, construction sites, rail yards and packinghouses. Even the female laborers who toiled in the

sewing sweatshops were invited to join in solidarity. The storm of strikes crippled Chicago's industry.

The labor protests were a direct challenge of the city's capitalist power. These men of great wealth and connection had long ignored the nation's first eight-hour workday law, passed nearly twenty years earlier by Illinois governor Richard J. Oglesby. Affronting political authority, they believed that the law reduced output and restricted employees' ability to earn wages through long unregulated hours. Finding ways to work around it, the law lay dormant in the books. All the while, the working class labored six days a week for ten, twelve and even fourteen hours per day, often in harsh, dangerous conditions. The work stoppage of those first days of May was an economic blow intended to weaken the industrialists—even the docile employee residents of George Pullman's model town, just south of Chicago, were stirring. By hitting them where it hurt, the laborers' demands were being heard. One by one, the masters of capital gave in.

But over at the McCormick Reaper Works, business leaders had already made the decision to ignore labor demands and had invested millions to replace men with machines. In February, the company locked out union members, and knowing that the action was potentially dangerous, they hired security to protect the replacement force. On the afternoon of May 3, anarchist agitators addressed a large rally near the factory. As the nonunion, nonstriking McCormick workers exited the factory at the end of their shift, they headed for the taverns or home. But on this fateful day, they were confronted by those attending the workers' rights rally. A melee ensued. Police were dispatched, shots were fired and several men were wounded. Two workers lay dead. The rallying crowd reorganized as a lynch mob. With a readied noose hanging from a lamppost, they pursued an officer. He escaped, but one of the anarchist organizers, August Spies, used the incident as a call to arms. The anarchists ordered a protest meeting for the next day.

The rallying point was Haymarket Square, an open-air market where farmers came to sell and trade produce. No historical narrative seems to address why this location was selected; however, it may have been chosen to inform and disrupt the farmers, as they were the ones who kept McCormick in business and fed Chicago's powerful grain industry. After several hours, under rain and advancing evening, the nonviolent crowd began to dwindle. In a quick turn of events, a speaker used provocative language against the police. Upon command, 176 officers marched forward. A bomb was hurled into their ranks. In a matter of minutes, 60 officers were injured, 1 died

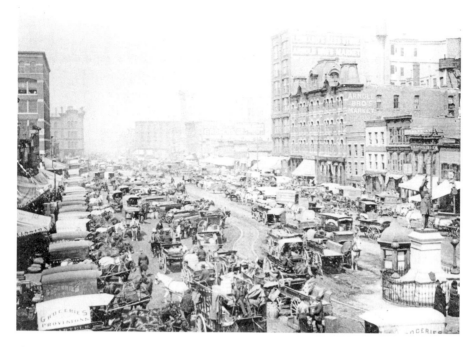

The Haymarket on Randolph Street, with the statue honoring the police officers who were killed. *Library of Congress.*

instantly and another 7 were fatally wounded. History did not record how many of the assembled were wounded or killed. Hundreds were arrested. Among them were 8 men who would become the martyrs of the international struggle for workers' rights.

Despite the fact that the identity of the bomb thrower was never determined, the eight anarchists (who were prominent speakers and writers) were tried for conspiracy to murder. The anarchist ideology was one that rejected private property and government, and they were supported by Karl Marx. It was a red scare that government and civic leaders wanted oppressed. Six weeks after the incident, a purposefully selected prejudiced jury convicted the men. In the wake of what is now considered one of the worst miscarriages of the American judicial system, four of these men went to the gallows as two hundred spectators watched, one committed suicide while imprisoned and three were eventually pardoned. Among the men who were hanged was Albert Parsons. He had already departed the meeting when the bomb was thrown. At that fateful moment, some accounts had him at Zepf's Hall, drinking a schooner of beer.

On Memorial Day 1889, a statue was installed at the site to commemorate the incident. But it was a statute honoring the police rather than the laborers of the city. Immediately, this first U.S. monument honoring fallen police officers became a target of vandalism. In about 1900, it was moved to nearby Union Park. Although the park's name honors the Federal Union, not labor unions, the irony can't be overlooked. In the 1950s, the statue was returned to a location near Randolph and Des Plaines in an attempt to draw visitors to the now downtrodden area.

Even with the passage of several decades, the statue continued to symbolize and provoke conflict. On October 6, 1969, and again the following year, radical students used dynamite to blow the statue apart. Nearby windows shattered, and metal parts rained down on the relatively new interstate. Enraged, Mayor Daley assigned twenty-four-hour police protection to the repaired statue. The historic landmark remains under such protection, as it is now housed in an interior courtyard of the Chicago Police Headquarters. The martyrs, on the other hand, were honored with a monument in 1893. Erected at their grave sites at Forest Home Cemetery, it has become an icon of the international labor movement and was designated a national historic landmark in 1997. Its base is inscribed with the last words spoken by August Spies: "The time will come when our silence will be more powerful than the voices you are throttling today." Sadly, very few Americans know about the movement, the massacre and the suppression of free speech that are together known as the Haymarket Affair.

Located near the incident site, the Haymarket Pub and Brewery honors the historic event with its changing menu of beers that regularly reference the historic subject matter. While the building does not have any apparent connection to the events, it does have some notable features and history of its own. A walk through the basement of Haymarket Pub and Brewery is a meander through a series of rooms and passageways that once served as the old sidewalks and streets of the city. From 1855 to 1858, the streets were raised anywhere between four to eight feet to facilitate drainage and to install an underground sewer system. Left to building owners, some existing buildings were raised to the higher street grade, while others simply changed their entryways. The original street-level windows have been bricked in, and old tracks are evident.

Streetcars were placed into service in 1859, so the origin of the tracks is a mystery based on the timeframe of the street regrading project. However, an elaborate tunnel and rail system operated under the streets of Chicago from 1906 to 1959. A 1914 map of the Chicago Tunnel Company shows

The basement of Haymarket Pub and Brewery is filled with remnants of the past. The old windows, which were once street level, have been sealed. *Photo by Denese Neu.*

this address one block away, and given the nature of the basement, these are likely remnants of the underground transport system that moved coal, mail, and merchandise between the railroads and businesses while avoiding the jammed city streets. The system was so extensive that it even had its own police force. In 1991, a tunnel wall was pierced and the system filled with water. Like the strikes of more than one hundred years earlier, the flood forced a city shutdown and resulted in considerable economic loss for Chicago's businesses. Today, portions of the system continue to be used for power and communications cables, a throwback to the system's origin in 1899. While the Illinois Telephone and Telegraph Company awaited city approval for its planned telephone network, it covertly excavated the first sixteen miles, working from the basement of a saloon.

The Haymarket basement holds other remnants of the past: a concrete vault, compressors from one of the first commercial building air conditioners in Chicago and mechanical devices of unknown purpose. During the brewery construction, the owners also discovered a "secret" room. After weeks of speculation, yours truly ventured forth. Upon squeezing through

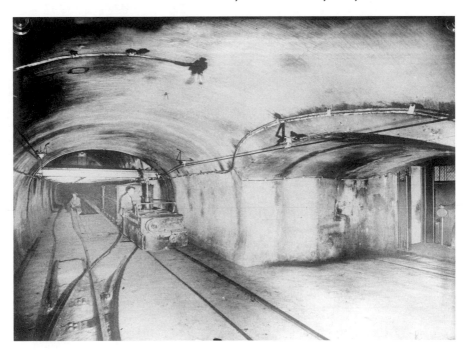

An undated photograph of men working in the Chicago Tunnel system that linked buildings throughout the downtown area. It was used to transport goods while avoiding street-level congestion. *Library of Congress.*

the narrow cobwebbed passage and under the gas pipe, the truth was revealed. Almost instantly, the flashlight batteries died. It was a graveyard… of old restaurant furniture. Rather than hauling it out, the previous tenants had merely erected a wall to hide the old bar stools from Barney's Market Club, which once occupied this location.

Starting as a little café with no more than twenty seats and no set menu, Barney's Market Club grew to be the top-rated restaurant in Chicago. Barney Kessel, the proprietor, grew up in the neighborhood behind the infamous Union Stock Yard, and from the beginning in 1919, he only served what was freshly available. In the 1930s, he moved from his location near the Polk Street station to the Randolph and Halsted location. Here, he would eventually serve an average of two thousand customers per day. The *Chicago Daily Tribune*'s social pages from Barney's heyday describe a generous owner and a balance between the familiar and swank. A "Holy Corner" table was permanently reserved for the Catholic clergy, and a fellow named Murphy was given a rent-free sales spot in the foyer. Donning loose-fitting clothes and loud ties, he became a fixture in the late 1930s when he

A Barney's Market Club advertisement featuring its trademark expression. The "Happy Days Are Here Again" slogan suggests that it most likely dates to the post–World War II years.

arrived to sell paper flowers. By the 1950s, his merchandise had expanded to a table with toys and miscellaneous gadgets. But Barney's was perhaps best known for its customer greeting that resulted from the owner having a poor memory for names. Rather than offend the powerful politicians who often patronized his place, all customers, regardless of class or position, were greeted with, "Yes sir, Senators." Kessel died in 1951, but Barney's remained open another forty years.

Some believe that the building has a permanent resident. According to the Haymarket proprietors, former Barney's employees stopped by during the recent renovations and regaled them with stories of that bygone era. They told of paranormal incidents. One storyteller claimed that a man had been shot and killed in the front bar—the same area where motion-sensor cameras were often triggered during the renovation—with no obvious explanation and no one present in the building. Research of the news and murder archives did not provide evidence, but this is Chicago and this was Barney's—a popular place for politicians, the powerful and the police.

LIMESTONE BREWING COMPANY
Plainfield, Illinois

THE BREWERY

Limestone opened at the end of 2009. It features a regular and seasonal lineup of its own beers, along with other craft beers. In addition to food and drink, it also hosts family movie nights, trivia and live music. Local historic brewery images, reproductions of advertising and business correspondence are also displayed for those interested in breweriana.

THE BAR STOOL STORY

About 425 million years ago, the portion of earth that would form Illinois sat below the equator. Covered by the waters of the shallow Silurian Seas, coral and exotic sea creatures lived and died. Over the eons, their skeletons hardened into dolomite and limestone rock, the bedrock that anchors today's skyscrapers and lines many of the historic façades.

Limestone Brewing Company pays homage to Plainfield's history with both brewery and beer names. Although Plainfield has an interesting heritage, today it is a typical exurban community, straddling suburban and rural edges. Plainfield experienced substantial growth in the 1990s and is now home to both historic properties and new strip malls, one of which houses the brewery. Taking its name from the area's limestone quarrying and production, the brewery salutes a significant economic activity tracing back to Chicagoland's early years. In the growing city and throughout the

region, the quarries and the stone works were major employers. By the 1850s, large quarries employed up to three hundred men each. Using the Illinois and Michigan Canal, the stones were then hauled to Chicago for cutting, polishing and distribution.

In the nineteenth century, stone was a popular building material laboriously extracted from the earth. Before the invention of specialized powered machinery, quarrymen were hand-laborers. For up to twelve hours, the dynamite blasted and the men chiseled out cords of limestone up to twenty feet long and blocks the size of refrigerators. To stay dry, the water seepage was carried out in pails, often by child laborers. A skilled laborer might earn up to fifteen cents per hour; an unskilled man, a nickel. At the end of the day, their take home was lessened by the cost of gloves that were purchased on a nearly daily basis, as well as other personal expenses tallied by the employer and deducted from their pay. The hours were long, and the work was dangerous. Injury and death were common occurrences. Those who weren't killed or disabled often fought lung disease caused by the limestone dust. As they carved, they uncovered the fossils of prehistoric sea life. These fossils are now contained within façades, foundations and doorways throughout the city and region.

As land was stripped of building material, tunnels and man-made caves were formed. These natural cooling spaces solved another industry's problem: keeping the beer cold. Like the men who cut huge blocks of limestone, men labored through the winter months to cut huge blocks of ice. Even the most modern conveniences still required a great deal of labor, and refrigeration was not something taken for granted. With pickling, canning and salt curing, refrigeration wasn't fully necessary for food (although it did help maintain healthier diets). However, refrigeration was absolutely essential for breweries, such as the Sehring, Scheidt and Columbia Breweries in nearby Joliet, to store beer for the local residents.

Many men who worked the quarries also worked for local ice companies along the Des Plaines, DuPage and Fox Rivers. They harvested the ice during the coldest months, worked in the storage facilities and delivered blocks weighing up to one hundred pounds to nearby homes and businesses. Like the stone and brewing industries, it was labor intensive. For weeks, the men would scrape the snow off the ice, measure grids and guide the horses that etched grooves. Then, with a hand saw, each man cut through the grooves until the blocks broke loose and floated to the channel. From there, hooks hauled them up into the icehouse, where the naturally harvested ice was stored for use throughout the months ahead. These commercial icehouses allowed breweries to brew year round and the underground limestone

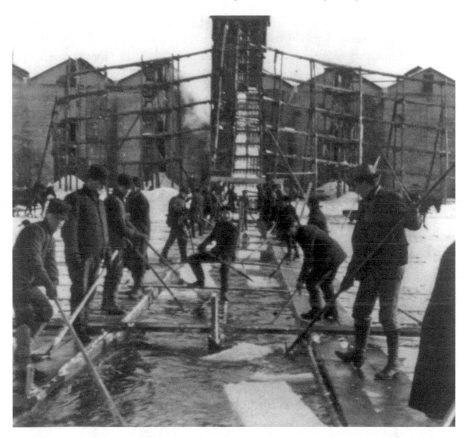

Ice harvesters pushing cut blocks toward the icehouses, where they would be stored for shipping. *Library of Congress.*

tunnels reduced the amount of ice required. The men who worked the quarries and ice harvests were likely regular customers of the taverns and saloons supplied by these local breweries.

But before there was industry, the area belonged to the natives. In 1828, a Methodist circuit-riding preacher established an Indian mission located just south of present-day Plainfield. Named Walkers' Grove, it was the first permanent settlement in Will County, and it sat on the very edge of the Indian Boundary lands. Ceded to the United States by the Fox and Sauk tribes in 1816, this twenty-mile-wide tract of land ran from Lake Michigan to the Mississippi River. The agreement was that white men were granted safe travel through this corridor. After a few years, Jesse Walker left the mission to travel throughout northern Illinois, preaching to both Indians and pioneers alike. His wife remained with her daughter and son-in-law, James

Walker, who, along with twelve other men and their families, constructed a sawmill in 1830. With it came more settlers, and with more settlers came industrial development associated with the area's natural resources.

The community members of Walkers' Grove worked and lived side by side with their Potawatomi neighbors in relative peace. But when news of expelled native tribes attempting a return to their homeland arrived, local settlers panicked. They formed a militia by banding together with Captain Holder Sisson's men from the nearby Yankee settlement. For protection, they disassembled their log cabins to construct a fort on the property of Reverend Stephen R. Beggs. The Black Hawk War had begun. Lasting only fifteen weeks, it led to the signing of the Treaty of Chicago, and with this document, all Native Americans were banished from Illinois. As their Potawatomi friends departed for western lands, many of the women and children of Walkers' Grove wept, knowing that they would never see them again.

With the people who were viewed as savages removed from the land, white settlers could now travel freely. Over the next several decades, Plainfield grew

Women stroll through Plainfield's Electric Park, circa 1904. *From the Collection of Michael A. Lambert, Plainfield, Illinois.*

from a mill and stagecoach stop into a village. When the Chicago Belt Line Railroad entered, the village became a grain storage and shipping point. Chicago's grain trade was growing, and it fed other industries within the region. As the economic growth took hold in nearby towns of Joliet and Aurora, an electric rail line was constructed to connect each community. Inaugurated in October 1904, the streetcar company went out of business in 1923 when bus service was introduced.

To boost ridership and promote the Plainfield stop as an entertainment destination, Electric Park was opened in October 1904. These amusement parks were part of a national trend that included the infamous Coney Island in New York City. Operating during the first few decades of the twentieth century, these parks received their name because they were either owned by the local electric company or accessed by the electric trolley lines. Built in a former cow pasture near the DuPage River, Plainfield's Electric Park quickly became a summer retreat area where people rented cottages, enjoyed concerts, watched baseball games and participated in river-based water activities. Like most of these promotional venues, Plainfield's was short-lived but managed to stay open much longer than many others.

After Electric Park closed, most of the park buildings were razed. Several cottages were saved, and after additions and alterations, they became family homes. The only significant structure that remained standing was the auditorium. Over the years, it served a variety of uses, including as a warehouse, a radio station, a skating rink and a dance hall. Eventually, it would be used as a bus barn by Plainfield Community School District 202; this was its use when it was destroyed on August 28, 1990.

Late in the afternoon on that fateful day, an F-5 tornado hit without warning. Touching down in Oswego and traveling southeast toward Plainfield, the tornado struck the Wheatland Plains subdivision northwest of Plainfield at about 3:28 p.m. The former Electric Park auditorium was demolished, and the twister moved on. With only minutes to react, high school athletes ran into the school, only to have the building collapse around them. Only the hallway and gymnasium in which both the football and volleyball teams had sheltered were spared. Moments later, Saint Mary's Immaculate Catholic Church and school were destroyed, along with numerous homes and businesses that lay in the tornado's path.

In 1990, Plainfield was a small town of 4,500, yet the event was so devastating that it made international news. Donations came from around the world. Even the United States' sworn enemy at the time, the Soviet Union, offered help. The storm took the lives of 29 people (9 from

An aerial image of the local high school destroyed in the F-5 tornado. *Plainfield Public Library.*

Plainfield) and injured more than 350. Measured at seven hundred feet wide, it cut a 16.4-mile-long path of destruction. Along with Plainfield High School, two additional schools and several municipal buildings were destroyed. More than one thousand homes and business were destroyed or damaged. In all, the Plainfield tornado caused more than $140 million worth of damage. These are the tragic statistics of a community scarred by nature.

In the aftermath of any disaster, policymakers, planners and social scientists sift through the damage to determine the lessons. At the time of this storm, the Chicago office of the National Weather Service was responsible for providing forecasts for the entire state of Illinois. On that particular day, staff were so overwhelmed by the storm cells that they couldn't keep up with the workload. Tragically, the tornado warning wasn't issued until after it had already lifted back off the ground. After this event, changes were made within the National Weather Service to allow local offices to issue forecasts for their respective areas.

The 1990 tornado wasn't the first tornado to hit the area, and it is highly unlikely that it will be the last. The brewery recognizes these risks and events and originally named one of its beers F-5 Flying Pig. The "F-5" was dropped when a local couple, who had lost their child in the 1990 tornado, expressed that the beer name trivialized the incident. However, Flying Pig remains on the menu—not as an expression of improbability (as in, "when pigs fly") but as an homage to a story associated with another tornado that struck in 1920. In the wake of that storm, a farmer emerged from the underground cellar. When he entered his house to inspect the damage, he found that the tornado had picked up and carried his pigs from their pen. There on

his kitchen table, one of them lay…sound asleep. It's true—strange things happen during tornados.

While many of the area farmers were known abstainers, this was the early days of prohibition. Who knows? Perhaps he had enjoyed some stowed-away beer while down in the storm cellar.

METROPOLITAN BREWING

Chicago, Illinois

THE BREWERY

The husband-wife team of Doug and Tracy Hurst opened Metropolitan in late 2008. Not too long after, the brewery was the venue for the premiere of Drinking and Writing Theater's *BEER!* (a puppet musical about the brewing process). They now work like crazy to keep up with demand for lagers in a craft beer city of mostly ales. Their brewery is tucked away in the North Side neighborhood of Andersonville, which is home to several great beer bars that feature Metropolitan beers.

THE BAR STOOL STORY

Metropolitan Brewing has brought traditional German lagers back to the local market. Although this style wasn't the first beer brewed in Chicago, it quickly became the most widely consumed during the last half of the nineteenth century.

Brewing in Chicago began in the 1830s with local taverns producing small batches to supplement the shipments of East Coast beer. The first commercial brewery was located on Pine Street (now Michigan Avenue aka "the Magnificant Mile"). With a change in ownership in about 1841, the brewery became known as Lill and Diversey, producing English-style ales and porters for the city's fast-growing population. The United States militia was driving the Native Americans west and opening the frontier.

The *Sea Bull* that oversees brewery production. Sculpted and installed for the 2009 production of *BEER!* (a puppet musical about the brewing process), it was named in honor of Dr. John Ewald Siebel, who modernized the brewing process from his lab in Chicago. *Photo by Denese Neu.*

With the promise of fertile prairie, fledgling Chicago became a place of opportunity for farmers and skilled workers alike. Among the arrivals were German immigrants fleeing religious oppression, political upheaval and economic hardship in their motherland. Many of these early Germans were scholars, skilled laborers and engineers—all necessary talents for building the infrastructure and economy of a new city. As they brought their skills, they also brought their thirst for beer, and with ever increasing demand, the breweries kept opening and brewed beer to match their tastes.

By 1850, Germans made up one-sixth of Chicago's population, and their numbers had largely settled on the near North Side. The area became known as "Norde Seite" and was home to an abundance of ethnic organizations, beer gardens, taverns and German-owned breweries. For the new immigrants and working class, these gathering places were important points of entry to their new lives. They helped them find jobs and housing and provided a valuable social network for maintaining traditions while entering American society. At about the same time, the Know-Nothing

political movement was gaining a foothold in Chicago. Driven by fear that large numbers of German and Irish Catholic immigrants would challenge the moral values of the dominant Anglo-Saxon American culture, the party strove to curb immigration. Although only powerful for a few years, Know-Nothing political candidates were elected to office throughout the United States. When Levi D. Boone was elected mayor of Chicago, one of his first official actions was to bar all immigrants from city jobs. To be considered for municipal work, every applicant was forced to prove that he was born on American soil. The religious differences were also a political issue, and the anti-Catholic temperance movement began. In an effort to oppress the alcohol-consuming immigrant Catholics, Boone raised the liquor license cost from $50 to $300 and decreased the licensing term from one year to three months.

In addition to the high-cost liquor license, the mayor ordered the police to enforce the long-forgotten Sunday closing law. Sunday, the only day off work for many of Chicago's immigrant laborers, was a day of gathering in the beer gardens and taverns—even the women joined the festivities and imbibed. Chicago's temperance laws were a direct assault on the cultural habits and social drinking customs of the Germans, and they protested through noncompliance. The German saloonkeepers united in refusing to pay the fees or close their doors on Sundays. In response, Levy mobilized the newly organized nativist police force. In a sweep of the Norde Seite, two hundred saloonkeepers and bartenders were arrested. The German populace responded by raising defense funds. The hearing was set for April 21.

The Know-Nothing party held political power over a city in which about half of its residents were foreign born. Sociopolitical lines had been drawn with the alcohol ordinances, and nonnatives became restless under the oppression. Other foreign-born groups, such as the Irish and Scandinavians, aligned themselves in solidarity with the Germans. On the day of the hearing, people streamed from across the city to amass outside of the courthouse. Strong in number, they barricaded Clark and Randolph Streets. Mayor Boone, with the courage of his convictions, ordered the police to disperse the mob and clear the streets. This was the first recorded episode of this order being given, but it is one that would be repeated many more times throughout Chicago's history.

Men who offered resistance were arrested and jailed, and eventually the assembled masses were driven off. The North Side immigrants were not finished. In retreat, they prepared a stronger attack with the intent to take

over the jail and rescue the prisoners. Upon learning of the coming raid, the mayor prepared. By raising the Clark Street drawbridge, he held the armed group off. Quickly deputizing new officers, his forces increased in power and assembled. The bridge was lowered, the rioters surged forth across the river and battle ensued. Sixty more men were arrested. Although scores were wounded on both sides, only one official death is attributed to the incident. But lore has it that there was a steep increase in North Side funerals in the days that followed. As for the arrested men, nearly all of the cases were eventually dismissed.

This incident would become known as the Lager Beer Riot. It was Chicago's first major episode of civil disobedience and helped to define the city as a place where the masses engage in civil action by taking to the streets. The riot, while not successful in its primary intent, did serve to mobilize Chicago's immigrants. During the elections of 1856, the foreign-born population turned out in force to defeat the nativists. The legacy of the event would stretch into the next century as a battle between anti-saloon reformists and political candidates (often corrupt) seeking support of the immigrant beer drinkers and saloonkeepers.

Immigrants continued to come to Chicago in droves. By 1870, Chicago's population had reached nearly 300,000, with Germans composing the largest immigrant group. During the Great Fire of 1871, they sustained great losses

A Chicago water tower, one of the few structures to survey the Great Fire of 1871.

but also played a significant role in the city's rebuilding—one that started while the fire raged. As the terrified populace fled to the prairies, Frank Trautman stayed behind. A prominent member of the German community, he was also the chief engineer for the city's newly built water tower—the historic water that remains today. Legend has it that along with his assistants, he soaked sails and blankets in Lake Michigan to save the structure. With this heroic act, water service was quickly restored to the destroyed city. As for the Lill and Diversey Brewery next door, it was lost to the flames and would never reopen.

Germans would continue to dominate the brewing industry—among them was Charles Wacker. Beyond the beer, he was perhaps the most significant German to play a role in shaping modern Chicago. In addition to being a brewer, he also served as chairman of the Chicago Plan Commission from 1909 to 1926, and it was for this role, not the beer, that the three-story Wacker Drive was named in his honor. Also among them was Theodore Thomas, who from an early age played the violin at weddings and balls and in taverns. In 1845, his family immigrated to the United States, convinced that America would provide a better life for a respected musician. His career would eventually come to an end in Chicago, but it wasn't a career spent performing in the German taverns. In 1891, he founded the world-renowned Chicago Symphony Orchestra, for which he served as music director until his death in 1905.

Other German success stories of Chicago include that of Oscar Mayer, the meatpacker, and Julius Rosenwald (a German Jew), who built the Sears and Roebuck Company. Also included in this cadre is Danmark Adler, a man who is still ranked among the world's most influential architects. Immigrating to the United States in 1854, he came to Chicago a few years later to work as a draftsman. During the American Civil War, he served as a master bridge builder, which gave him the skills to tackle building on Chicago's swampy terrain. With his innovative engineering, he became the first to use concrete foundation for stabilizing structures. As he continued to develop new advances in construction and materials technology, his partner, Louis Sullivan, designed a new architectural style. Together, they created what became known as the Prairie School of Architecture and trained the young Frank Lloyd Wright. From 1880 to 1895, Adler and Sullivan designed about 180 buildings, including the Chicago Stock Exchange. Although this partnership would not survive the economic depression of 1893, the firm of Adler and Sullivan continues to influence the Chicago skyline and architectural landscape to this day.

The German presence in Chicago began to erode when World War I pushed the ethnicity and heritage into hiding. As the Great War raged in Europe, anti-German sentiment ran strong, and many families and organizations changed their names to sound more American. This same anti-German sentiment aided the passage of prohibition, as the Anti-Saloon League used the war to attack the American brewing industry, which was largely controlled by Germans. The brewers were linked to German heritage organizations, all suspect of being enemies of the state.

The arrival of prohibition marked the end of Chicago's great beer halls, beer gardens and breweries (although some continued to illegally brew for gangsters like Johnny Torrio and Al Capone). A few decades later, World War II would again force German Americans to distance themselves from their heritage. Following that war, a new wave of German immigrants arrived and settled the areas of Lincoln Square, Bowmanville and Ravenswood, neighborhoods adjacent to Metropolitan Brewing. It seems that the anti-

Metropolitan pays homage to Chicago's industrial history. This historic piece of mechanical equipment was manufactured in Chicago more than one hundred years ago and still operates the elevator at Argus Brewery. *Photo by Denese Neu.*

German sentiment lasted well into the twentieth century—at least in regard to beer. A 1998 advertisement from another Chicagoland brewery proclaimed with pride: "It's Not German."

The owners of Metropolitan, however, do take great pride in bringing traditional German lagers back to the city that they respect for its industrial history. With mechanization and the railways, the city evolved into a central location for production and the grain industry. By naming their beers after machinery parts (Dynamo, Flywheel and Krankshaft), they pay homage to the city's role of innovation. And with its logo featuring a Krankshaft with stalks of wheat, Metropolitan honors Chicago's great brewing days of yore.

MICKEY FINN'S BREWERY

Libertyville, Illinois

THE BREWERY

Mickey Finn's has been brewing since 1994, a relatively old craft brewery in the Chicago area. It has a small lineup of regular beers and an extensive list of rotational/seasonal beers. Some beers are packaged and sold for off-site consumption. In addition to the bar and restaurant, it has a party room that regularly books live bands.

THE BAR STOOL STORY

Housed in two adjoining buildings, across from Libertyville's historic town square, sits Mickey Finn's brewpub. One building, constructed in 1984, is infill, but the main bar sits in a 125-year-old building with a long history of serving alcohol to the thirsty public. Believed to have been a bar before prohibition, it was a popular barbershop during the dry years. Lore has it that the basement was used for the delivery and distribution of outlawed alcohol. The remaining original back door, with its crudely drilled peephole, provides suggestive evidence that this might have indeed been the case.

From 1920 to 1933 (the years of the "Nobel Experiment"), Illinois was a hotbed of the bootlegging industry. Despite the laws against alcohol, the masses remained thirsty. Almost immediately, illegal breweries and distilleries began operating to meet their demand. Libertyville, a sleepy rural town, was a perfect place for clandestine transactions, although it didn't fully avoid the long arm of the law. On October 11, 1923, a moonshine still

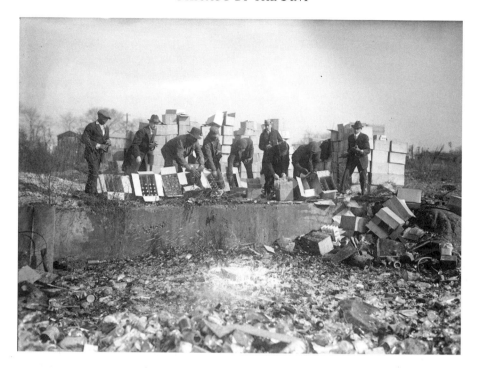

Alcohol consumption increased during the years of prohibition. When illegal shipments were confiscated, they were often destroyed, but many bottles landed in the hands of corrupt agents and made their way back to market. *Library of Congress.*

was seized at a nearby farm. During the Prohibition era, the population of Libertyville nearly doubled, from 2,125 to 4,100. Irrespective of this population boom, the demand for shaves and haircuts fell drastically upon the repeal of prohibition in 1933, and the barbershop was closed. Matthias Sloan reopened it as the Parkview Tap shortly thereafter.

The Parkview Tap remained open until 1978. In honor of this heritage, Mickey Finn's front bar displays a 1930s photograph of Parkview Tap patrons. Surrounding the same bar in use today, the men in the photo line the bar, with the women seated at a nearby table. With the exception of bars catering to immigrants from eastern Europe, where beer consumption was a part of everyday life, it was not common practice for respectable women to drink in saloons, and many banned the presence of women altogether. Those that did allow women usually reserved the bar for men only and provided tables and chairs for the women. In fact, the Chicago City Council voted to prohibit women from standing at bars. With the Women's Christian Temperance Union headquartered in nearby Evanston, the ordinance was

an attempt to segregate woman and reduce the risk of prohibitionist ideas again creeping in. The ordinance was quickly rescinded, but some continued to believe that women simply didn't belong in drinking establishments at all. Holding tight to the idea that the saloon was a place to escape the pressures of work and family, the famous Berghoff of Chicago maintained a segregated bar for men only. The restriction wasn't lifted until 1969, when seven women from the National Organization of Women (NOW) went in, bellied up and demanded service. At the Parkview Tap, migrant farmworkers were also welcome, and following a common practice of the day, the bar would cash the workers' checks so that they could commence drinking before heading home with their pay, if there happened to be any left.

In addition to the legends associated with the previous tenants, Mickey Finn's is believed to be haunted, and numerous strange encounters led the current owners to investigate. In 2004, a group gathered for a facilitated séance in the basement—the location of most of the eerie incidents and feelings. Within a short time, the participants streamed from the basement

The grandeur of the World's Columbian Exposition, held in 1893. Only two decades after Chicago was destroyed by fire, the city's leaders won a hard-fought battle to be selected as the site. *Library of Congress.*

in tears. A man's spirit had contacted them and conveyed that he was not at rest in his basement burial place—a basement that originally had a dirt floor but had been quickly covered in concrete poured in through a street-level window.

The brewery takes its name from the legendary criminal Mickey Finn. Likely drawn by the promise of prosperity surrounding the World's Columbian Exposition, the not-yet-notorious Irish immigrant was first reported in Chicago in 1893. Unlike those who arrived for the spectacle and jobs, he came for another type of opportunity: easy crime in the city's notorious vice districts. In the years following the fire, several vice districts had taken hold under the protection of the corrupt First Ward aldermen "Bathhouse" John Coughlin and Michael "Hinky Dink" Kenna. Among the vice districts were Little Cheyenne, Satan's Mile, Hell's Half-Acre and the infamous Levee District. Concentrated in what is now Chicago's South Loop and near South Side, the area was nothing but high-density bordellos, saloons and gambling dens. When the Chicago Vice Commission released its report in 1911, more than one thousand brothels were operating, and at least five thousand women were working as full-time prostitutes.

Mickey Finn worked at mugging and robbing the drunks of the Levee District. This area was where the poor worked and drank and where unsuspecting women were placed into white slavery (forced prostitution). It was also where the elite men of the city and visitors would go to gamble, imbibe and play with the women at the high-class Everleigh Club, one of the most prestigious brothels ever established in the United States. The club was so renowned for the lavish treatment of customers and the respectful care of the women that a waiting list to work there was maintained by the madams. Prostitutes from houses as far away as New Orleans and Oklahoma City applied. Meeting the quality standards demanded for the wealthy industrialists and politicians of Chicago was their ticket to a better and safer life.

After a few years of working victims over on the streets, Mickey Finn became a saloonkeeper and used his joint to mark his targets. From 1896 to 1903, he ran the Lone Star Saloon and Palm Garden Restaurant. Palm Garden was a popular name for the lush indoor beer gardens that had become vogue during the 1890s, with the most famous owned and operated by the Schlitz Brewing Company in Milwaukee. Alternately, Mickey Finn's establishment reportedly had only one scrawny potted palm. Located in what is now the city's South Loop area, scholars and historians continue to debate the exact location. When Chicago's street address system was modernized in the first decade of the twentieth century, it caused confusion in the records. Street

numbers were reset to register distance and direction, and not every previous address was recorded with the associated new address. Streets were also renamed to eliminate the chaos caused by the municipality having multiple streets of the same name. One map places the Lone Star across the street from the Apollo Theater, where notorious masquerade balls of the 1870s and 1880s were held. Sponsored by the politically powerful, the "professors" (brothel musicians) played while the dancers removed masks and clothing at midnight. But by the 1890s, the Apollo had become a watering hole filled with drunks, pimps and low-class whores.

The Lone Star Saloon was where Finn developed and regularly practiced a new robbery technique—the one for which his name now lives on in legend and lore. According to various accounts, he would dose his customer's drinks with chloral hydrate. One story suggests that he received the drug as a potion from a voodoo doctor. From whomever or wherever he obtained it, one thing is certain: it knocked the unwitting customer out.

Finn's house girls flirted, encouraged drunkenness and entertained the men in any manner for which they would pay. For a portion of the take, they would often assist Finn with his crimes. Once incapacitated, the victim was escorted to a back room, robbed and left abandoned in a nearby alley. One of these girls was "Gold Tooth" Mary Thornton, nicknamed so for her gold tooth—her only tooth. But her loyalties weren't with Finn. With the Aldermanic Graft Commission investigating the city corruption that allowed the vice districts to operate, she ultimately talked and testified against him. At the end of the investigation and ensuing trial, the Lone Star Saloon (along with hundreds of others) was ordered closed on December 16, 1903. The local saloon industry, gambling, prostitution and crime were no longer under police and political protection. The $20 million industry eventually collapsed after a 1907 magazine article exposed Chicago's sordid underbelly to the world.

Finn eventually resurfaced, but different accounts place him in different locations. Some say that he was a bartender in the Loop. Others report that he was arrested in 1918 for running an illegal bar at 115th Street and the Calumet River, just a few blocks from Schlitz Row. In that same year, more than one hundred waiters were taken into custody on charges of drugging customers. Apparently, the practice of drugging nontipping and poorly tipping customers had become a widespread way to take more money. It is believed, but not validated, that this is the origin of the term "Mickey Finn" and the expression "slipped a Mickey." The term entered the mainstream lexicon with the 1930 novel *The Maltese Falcon*, which was made into a 1941 film starring Humphrey Bogart.

An undated image of Libertyville's main street shows that the town had at least one Schlitz Tied House.

There are several versions of the Mickey Finn story, with little pieces floating here and there. Just how much is fact and how much is fiction is uncertain. But Mickey Finn was indeed a real person, and he did operate the Lone Star Saloon in Chicago's once infamous vice district. He had nothing to do with Libertyville, and when the new proprietors purchased the brewpub, there was some discussion about changing the name—the owner's wife at the time simply found Finn's character to be offensive. But the name stayed, and the lore of Mickey Finn (but not the practice) lives on through the beer.

The Onion Pub and Brewery

Lake Barrington, Illinois

The Brewery

The Wild Onion Brewing Company was founded in 1995 by the Kainz family. In 2003, they moved the brewing company from a warehouse to their new Onion Pub and Brewery. It features a line of regular beers on tap and in cans (the website lists retail locations for those who would prefer to not travel for the bar stool story).

The Bar Stool Story

In 1603, French colonists began arriving in the Great Lakes area. Settling mostly in what would become Canada and Michigan, they expanded the fur trade and established Christian missions aimed at converting the natives. Dependent on the native peoples for trade and survival, members of the groups coexisted and even lived among one another. Believing that a short, easy passage existed to Asia, the French sought to find a river passage across North America and used the Indians' knowledge of geography to guide their exploration and secure territory for France. In 1645, Louis Jolliet was born in a French settlement near Quebec City. Growing up among the natives, he spoke several of their languages and initially sought Jesuit priesthood in order to help convert them to Christianity. Instead, he became an explorer. Joined by Father Jacques Marquette and five French-Indian voyageurs, they set out in two canoes to find the passage to Asia.

On this journey, these two men became the first Europeans to discover and travel the upper Mississippi River. Traveling along Lake Illinois (now Lake Michigan and the Fox River), they then portaged their canoes about two miles to the Wisconsin River, which carried them to the Mississippi River. Their expedition then traveled more than one thousand miles south. Their encounters with natives carrying European goods forced them to stop within 435 miles of the Gulf of Mexico. They were close to Spanish territory and Spanish colonists. Fearful for their safety, they turned back north.

Along the return journey, they learned that the Illinois River provided a shorter route back to the Great Lakes and French Canada. Guided by natives, the explorers followed the Illinois to the Des Plaines River. Then they cut across the Chicago portage, an eight-mile swamp that connected the Des Plaines to the Chicago River, which flowed into Lake Michigan. A year later, they returned to the Illinois Territory as welcomed guests of the Illinois Confederation of tribes. With this protection, they became the first Europeans to stay through the winter in what would become the city of Chicago.

The etymology of the name "Chicago" derives from a plant's name in the Native American Miami-Illinois language. "Chicagou" or "Checagou" has multiple spellings and translations, but all of them refer to the offensive smell of the natural landscape during the time of the explorers. The word has been interpreted to have meant "wild onion," "skunk," "stinking place" and "land of the stinking onion"—all pointing to the native wild onion and garlic plants that grew abundantly in the wetlands.

The plant was documented by the soldier-naturalist Henri Joutel. Traveling with the French explorer Robert de LaSalle (who claimed the area for France), Joutel documented the flora of the area. But he incorrectly recorded the native plant as *Alllium cernuum*, the nodding wild onion—a historical error that would stand for three hundred years. In the 1990s, research revealed the real botanical name as *Allium tricoccum*. The plant that gave Chicago its name was the ramp, which explains why some references call it garlic while others call it onion. This once abundant plant is now a rare and protected species.

Like Chicago, the Onion Pub and Brewery derives its name from this plant that once proliferated the lower Lake Michigan landscape. Located in Lake Barrington, the brewpub is thirty-five miles north of where Fort Dearborn stood at the mouth of the present Chicago River. Built in 1803, Fort Dearborn was constructed almost immediately after the territory was transferred from France to the United States with the Louisiana Purchase. It was at this point that Chicago became the official place designation.

Unlike the swampy lands around the Chicago River, the Lake Barrington area was fertile prairieland, a place where Native American tribes had farmed and hunted for generations. Although the Louisiana Purchase gave the United States control of the land, the government still had to deal with the people who populated the area. Rather than respect the rights of the Indians, these native settlements were forcefully removed so that white settlers could claim the land. The natives did not always go peacefully. Through the disputed 1804 Treaty of St. Louis (there would be a dozen more treaties of the same name), the United States negotiated possession of the land from the Sauk and Fox tribes. Ceding a swath of land that stretched across most of Illinois, southern Wisconsin and northeast Missouri, the tribes received $1,000 in goods per year. Signed by future U.S. president William Henry Harrison, the treaty was rejected by the Sauk on the belief that Quashquame, who represented the tribes, did not have the authority to sign. The Sauk warrior Black Hawk was particularly resentful of the treaty and did not go willfully.

In the late 1820s, the militia and white settlers gradually forced the tribes across the Mississippi River. But in 1832, the sixty-five-year-old Black Hawk

The Chicago Lithograph Company's depiction of the settlement in 1820. It shows the three branches of the Chicago River, Fort Dearborn and Du Sable's homestead. *Library of Congress.*

led men, women and children back to their homeland. Accounts suggest that this was a peaceful move, but the tribe's return prompted fear throughout northern Illinois. Settlers, the U.S. Army, Illinois militia and opposing tribes mobilized, and war was declared. Lasting only from April through August, the Black Hawk War marked the end of Native Americans in Illinois.

Under pursuit by the militia, the tribe retreated west. Along the trail, they were forced to abandon their weakest members to starvation and slaughter. The tally of dead is unknown, but an estimated four hundred Native American lives were lost in the Battle of Bad Axe. Led by Black Hawk, the surviving tribe members finally reached the eastern bank of the Mississippi River—safety was on the river's western shore. On August 2, the U.S. Army engaged. For eight hours, the guns struck everyone attempting to flee, including women with children running for cover or attempting to swim across the river. This slaughter was the final battle of the Black Hawk War.

Shortly after, the 1833 Treaty of Chicago was signed. With this document, the Potawatomi and other Indian nations ceded all northern Illinois land between Lake Michigan and the Winnebago River (Rockford, Illinois) to the United States. Most tribes migrated west toward Kansas, but some moved north into Wisconsin, where the Potawatomi continue to live on reservation land. Today, Black Hawk's name inadvertently lives on. In 1926, when

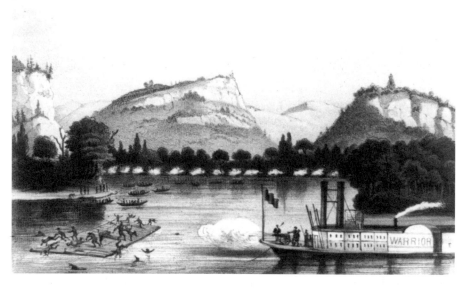

A German lithographic depicted the Battle of Bad Axe along the Mississippi River. *Library of Congress.*

professional hockey came to Chicago, the team was named after the owner's former army division—the division had been named in homage to the Sauk warrior. The team's logo, a cartoonish image of the warrior, has drawn controversy, as some consider Native American sports logos to be racially insensitive. It's doubtful that anyone has proposed that the team return to its original name…(wait for it)….Rosebuds.

With the Native Americans successfully driven west, the land was now available for settlement. To encourage western migration, the U.S. government offered the land cheaply to homesteaders. One of the first white settlers was Hugh Davlin, who arrived in about 1836. Without the benefit of roads, he staked his claim to fertile land at the intersection of two Indian trails. He then waited until 1840 for the U.S. government to finish surveying the land so it could be sold and officially transferred. During the wait, other settlers arrived, lands were cleared and farms were cultivated. Then the railroad arrived in the 1850s. With the eased transportation to the fast-developing city of Chicago and the production of the McCormick reaper, both the farms and local commerce prospered. They not only helped feed the growing urban population, but they also helped feed the grain trade that was helping build the economy of the new city. In the aftermath of the Great Fire of 1871, some of Chicago's grain merchants relocated to the area and built opulent Queen Anne–style homes.

In the late 1800s and early 1900s, Chicago residents regularly took respite in the small communities surrounding the city. Devoid of natural lakes, this area lacked the water resources needed to establish itself as a summer resort area. In the summer of 1924, a Chicago industrialist and president of one of the area railroads purchased seventy acres of farmland. Creating partnerships to develop the land, earthen dams were constructed to create lakes, and plans were laid out for a summer resort. But only a few cottages had been built when another businessman discovered the area. With Chicago continuing to grow rapidly in both size and population, land was increasingly hard to find. In the 1940s, subdivision plats were recorded for undeveloped lands, and in 1946, a six-hundred-acre estate was purchased for the purpose of subdividing and developing a high-density residential complex. Zoning battles ensued, and in 1959, Lake Barrington and North Barrington voted to incorporate independently of each other. With additional zoning protections, the Barrington area has resisted the heavy development and urban sprawl that has defined much of Chicagoland during the past several decades.

The Onion Pub and Brewery overlooks an eleven-acre lake formed from a quarry that had provided the gravel for highway development in the 1950s.

The brewery owners purchased the lake in 2000 and have undertaken restoration of both the lake and the surrounding prairieland. According to legend, Louie, a one-hundred-pound catfish, makes the fuselage of a drowned commercial airliner his home. You will have to trust the brewery owners on that one.

PIECE BREWERY AND PIZZERIA

Chicago, Illinois

THE BREWERY

Piece, a pizzeria with an on-site brewery, opened in 2001. It has several taps featuring a regular line of brews. It's a good place for watching sports, as well as enjoying the karaoke crowds on Thursday and Saturday nights.

THE BAR STOOL STORY

Piece Brewery sits in a popular neighborhood where barflies, back alley negroes, pimps and elderly ex-whores once ruled. With its Golden Arm ale, the brewery pays homage to a former denizen, the late author Nelson Algren.

The people of the streets and backroom joints were the characters of Nelson Algren's Chicago of the 1940s, '50s and '60s. The prose poet of Chicago's slums was a champion of the forgotten has-been. He took free meals at the missions—sometimes to listen and capture the stories of inhumanity among the urban landscape, sometimes to avoid going hungry himself. He walked the streets and plied alleys to experience what he called the most American city: Chicago. He called it this because it was a place that exposed the guilt of having nothing on the faces of those with nothing. The guilt of having nothing in a place built on the virtue of hard work and ownership. It's "The City of Big Shoulders" (from *Chicago Poems*), put to prose by Carl Sandburg, the poet who preceded Algren:

Nelson Algren reading Nelson Algren. *Library of Congress.*

Hog Butcher for the World,
Tool Maker, Stacker of Wheat,
Player with Railroads and the Nation's Freight Handler;
Stormy, husky, brawling,
City of the Big Shoulders:
They tell me you are wicked and I believe them, for I have seen your painted
women under the gas lamps luring the farm boys.
And they tell me you are crooked and I answer: Yes, it is true I have seen the
gunman kill and go free to kill again.
And they tell me you are brutal and my reply is: On the faces of women and
children I have seen the marks of wanton hunger.
And having answered so I turn once more to those who sneer at this my city,
and I give them back the sneer and say to them:
Come and show me another city with lifted head singing so proud to be alive
and coarse and strong and cunning.
Flinging magnetic curses amid the toil of piling job on job, here is a tall bold
slugger set vivid against the little soft cities;
Fierce as a dog with tongue lapping for action, cunning as a savage pitted
against the wilderness,

Bareheaded,
Shoveling,
Wrecking,
Planning,
Building, breaking, rebuilding,
Under the smoke, dust all over his mouth, laughing with white teeth,
Under the terrible burden of destiny laughing as a young man laughs,
Laughing even as an ignorant fighter laughs who has never lost a battle,
Bragging and laughing that under his wrist is the pulse, and under his ribs
the heart of the people, Laughing!
Laughing the stormy, husky, brawling laughter of Youth, half-naked,
sweating, proud to be Hog Butcher, Tool Maker, Stacker of Wheat, Player
with Railroads and Freight Handler to the Nation.

 Like Sandberg, Algren gave character to the city. But he exposed the
cruelty of the human condition, the urban condition, the conditions that
most prefer to pass blindly. It won him more enemies than fans while he was
alive. But he rejected wealth and pursued dignity for the impoverished. He
was an author of the people with no voice and often no choice left in life. His
subjects were his cohorts and companions in a world that can be unreasonably
cruel. He sympathized with the bums of Skid Row who reeked of piss and
alcohol. He socialized with junkies, ex-jailbirds and Marcel Marceau, the
internationally acclaimed French mime. With a standing invitation to the
Playboy mansion parties, he preferred the dingy, dank neighborhood bars
filled with miscreants and derelicts.

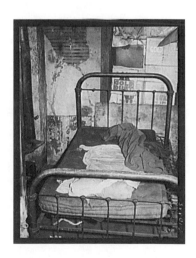

The interior of a black tenement house in 1940s
Chicago. Blacks fleeing the "separate but equal"
Jim Crow laws of the southern states were met with
substandard housing and segregation upon arrival in
northern cities. *Library of Congress.*

Algren drifted into his career during the height of the Depression. Upon graduating from the University of Illinois with a degree in journalism, he couldn't find work in Chicago. It was 1931. He hopped a train to New Orleans and absorbed the sensual city while working street scams for cash. From there, he took a boxcar to Texas with the hobos. He wandered and worked when he could, earning enough to usually buy a meal. His transient lifestyle took him from place to place until he found a small town with a classroom of unused typewriters. He hung around and wrote his first story. Upon departure, he decided to take one of the typewriters. He was caught, convicted for the theft and sent to prison. After release, he rode his way back to Chicago.

Algren was a heavy drinker and a compulsive gambler, both of which inspired his writing. Piece Brewery's Golden Arm is named after Algren's novel, *The Man with the Golden Arm*. It won the first-ever National Book Award in 1950. Algren's life and his buddy provided the inspiration for the Division Street ex-con card dealer and struggling addict portrayed by Frank Sinatra in the 1955 screen adaptation. If ever Algren had his chance to reap the financial rewards of his work, it was then. But he was just as inept at dealing with the literary agents as he was gambling. He sold the movie rights for a mere $15,000 because he tired of the conversation, and then he lost the money at the track. Otto Preminger, the man who pushed the lines of Hollywood censorship until they were relaxed in 1968, produced and directed the film. From the opening scene, which features a streetscape and seedy bar with "BEER" plastered across the window, to the heroin needle and suicide, Preminger confronts the social mores of the time.

Algren believed that Preminger cheapened the work, and he thought that Sinatra failed in his portrayal of a strung-out, card-dealing junkie. In fact, Sinatra's depiction of "Dealer" is more about picking a better woman than a warning to steer clear of addictive opiates. Algren believed that Marlon Brando should have been cast. But the actors were embattled in those years, and Sinatra signed for the role before Brando could accept the offer. Regardless of the casting and Preminger's treatment of the material, the movie provides a sense of the poverty in mid-twentieth-century Chicago and in the backroom gambling parlors.

Algren lived in a social world split between the poverty and wealth. He lived in poor conditions, but his lover was Simone de Beauvoir, the French novelist-philosopher. She's the woman who wrote *The Second Sex*, the foundational text of feminism. She belonged to Paris, and he shared her with Jean-Paul Sartre, the existential philosopher and writer who refused

the 1964 Nobel Prize for Literature. She traveled to Chicago often to share Algren's bed in his ten-dollars-per-month apartment. Their love affair lasted more than twenty years—he loved her most among his many lovers, and she once wrote to him that she was his wife. But his greatest love was Chicago, and hers was independence.

When he authored *Chicago: City on the Make*, he wrote an angry love letter to the city that let him down, broke his heart and spit him to the curb. He laid bare his soul and threw anger at the rusty urban heart. It is, perhaps, one of the finest literary examples of the urban form as character. And he may have crafted the ultimate line for anyone who has ever loved a place like a person: "Yet once you've come to be part of this particular patch, you'll never love another. Like loving a woman with a broken nose, you may well find lovelier lovelies. But never a lovely so real." City leaders didn't approve of the essay because it exposed the ugliness of the alleys and back rooms rather than featuring the thriving business community and façade that they wanted to project to the world.

Algren was a great American author. Ernest Hemingway (born in Oak Park, Illinois, in 1899) duly noticed. He once called Algren the best writer in America, second only to William Faulkner. Algren's literary work was respected in the great capitals of Europe but made enemies of Chicago from the beginning. In 1942, the large Polish population of Chicago railed against the depiction of them in *Never Come Morning*. They accused him of negatively portraying them as Nazi sympathizers. He defended his work as a depiction of the effects of poverty, regardless of race or ethnicity. They never forgave him.

He went from literary celebration to public and political censorship. His books were pulled from the Chicago Public Library system. A Parisian could more readily access his works than his next-door neighbors. Bruised by Simone and battered by Chicago, his love affair with the city faded. As poverty crept in, Algren pawned his National Book Award medal for $150. He sold *The Man with the Golden Arm* manuscript for the same amount. It is now owned by the University of Illinois. He eventually sold most of his belongings, including the desk at which he penned some of the greatest urban underbelly literature ever produced. After the sale in 1975, he was still nearly penniless. He departed Chicago for the final time. New York had work for him, and there he wrote what would be his final novel, *The Devil's Stocking*. Published posthumously in 1983, it is described as a fitting capstone to a career that sought truth and human dignity among grit and corruption. After his death, the City of Chicago reversed its position and renamed West Evergreen Street to West Algren Street. The Polish residents complained,

Nelson Algren's last Chicago residence. The once dilapidated apartment building has been restored and reflects the area's gentrification. *Photo by Denese Neu.*

and the name was quickly changed back. West Evergreen was where he had spent his final years as a Chicago resident. Algren died in 1981. Even in death, he did not return to the city that consumed him. He is buried on Long Island.

His longtime address of 1523 West Wabansia—only half a mile from the brewery—no longer exists. It was there where he wrote *Chicago: City on the Make.* The place was demolished for the freeway—a fitting end written by the city that broke the man. It's almost apropos that Golden Arm, the beer, is incorrectly announced on the World Beer Cup 2002 Winners List. It won a bronze medal as "Golden" from Arm Piece Brewery.

Two Brothers Roundhouse

Aurora, Illinois

The Brewery

In spring 2011, the Two Brothers Brewing Company purchased this brewpub and entertainment venue at auction. Since then, they have made several changes beyond just the name. The historic building has had some renovations and now features a gastropub, with several dishes prepared with their beer. This location features its regular line of beers, as well as exclusive Roundhouse beers. It hosts a courtyard tailgate party before Bears games and features live music on the weekends.

Author's Note: the following essay was researched and written before the brewery changed ownership. Some editing has been done, however the historical detail remains the same.

The Bar Stool Story

The year was 1886. Although Chicago's business was suffering under a nationwide depression, each day eight hundred freight and passenger trains entered and departed the city's six terminals. One hundred years later, the Chicago Bears won Super Bowl XX. Related? Not really, but these histories converge at this brewery that used to be America's Historic Roundhouse and Brewpub in Aurora, Illinois. But before it had that name, it was Walter Payton's Roundhouse Complex.

People knew Payton as No. 34, or "Sweetness." He was the player who defined the Bears for several years in the '70s and '80s. Some people say that he *was* the Bears. Voted the National Football League's Most Valuable Player in 1977, he went on to break Jim Brown's all-time rushing record seven years later. That same season, the Bears won their first postseason game since 1963. The following year, 1985, he led the team to Super Bowl XX. Anyone who saw the Bears' video hit, "The Super Bowl Shuffle," knows that the man could dance, especially in comparison to his teammates. Before that video, he also made a national appearance on *Soul Train* while attending Jackson State (Mississippi) in the early '70s. Payton retired as a player in 1987. Twelve years later, he faced the media with the announcement that he had been diagnosed with a rare liver disease. It claimed his life later that same year.

In 2009, the relationship between Walter Payton's estate and the Roundhouse ended. After years of disagreement over money owed to the family, Payton's family took charge on December 2. With the aid of a locksmith and movers, they reclaimed his belongings from the on-site museum and legally pursued having his name disassociated from the

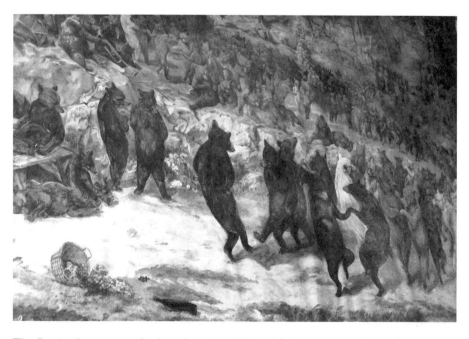

The *Dancing Bears* (a reproduction of an 1872 William H. Beard painting) was installed in the dining room as a playful homage to Payton's off-the-field dancing talent and his days as a Chicago Bear. *Photo by Denese Neu.*

establishment. Despite this ending, Payton not only left a football legacy, but he also left his mark by helping restore the historic Chicago, Burlington and Quincy (CB&Q) Railroad roundhouse. Built by J.R. Coulter in 1856, this is the oldest surviving roundhouse in the United States. Close to demolition after several decades of abandonment and neglect, Payton entered a partnership in 1995 to purchase and restore it for public use. For a job well done, the National Trust for Historic Preservation recognized it as one of the top fourteen preservation projects in 1999. It is notable that the first American dining rail car was constructed here, along with steam engines and Pullman hotel cars.

To fully appreciate the housing of the brewpub, a little more history and architectural detail are necessary. Built in the early days of industry and before major engineering advancements, a roundhouse is a simple semicircular or fully circular building with a turntable in the interior courtyard. They were most often constructed at the end of the rail line, where they could be fully

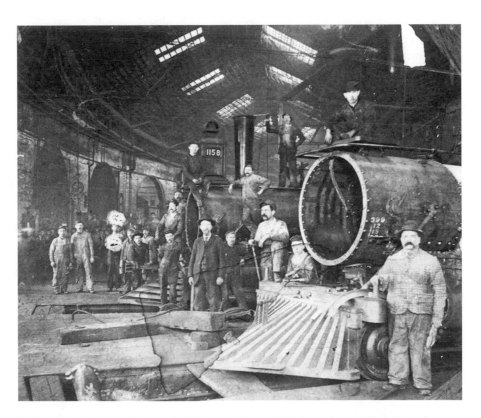

Railroad mechanics inside a stall of the roundhouse. This image is most likely from the 1870s. *Library of Congress.*

utilized. Steam locomotives were designed to move forward and forward only. Some sort of mechanism was required to reposition them around for the return journey, and the roundhouse served this purpose. The engines and cars were pulled through the bays into the courtyard, where a turntable would revolve to turn them around. The large bays of the building were used for storage, construction and repairs.

This CB&Q roundhouse originally had twenty-two bays. Eight more were added in 1859, and the final ten were constructed in 1864, for a total of forty bays. These different building phases resulted in bays of different sizes as locomotives became smaller and more powerful. Between 1863 and 1923, more buildings serving the railroad industry were added, including two more stone roundhouses. This structure is the original and the last remaining building of what was the largest rail car construction and repair shop complex in the Midwest. When the rail shops closed in 1974, most of the complex was demolished. This building sat empty and decaying for the next two decades.

The giant CB&Q got started on February 12, 1849, with a mere twelve miles of wooden rails. The tracks were expanded and eventually became the second railroad to serve Chicago, a city on the cusp of exploding. In 1851,

An undated picture of Aurora's roundhouse complex. Only the building that houses the brewery remains of what was once the area's largest employer. *Library of Congress.*

the city had a population of thirty-four thousand, which would increase tenfold over the next twenty years. In 1865, the CB&Q had the distinction of operating the first train into the newly opened Union Stock Yard. The ensuing massive growth of the yards would eventually give Chicago its reputation and moniker as the "hog butcher of the world." At the turn of the century, the stockyard employed twenty-five thousand workers who labored for ten to twelve hours per day in abhorrent conditions. Chicago would remain the center of America's meatpacking industry until the stockyard closed on July 31, 1971. The construction of the federal highway system and refrigerated trucking allowed the meatpacking plants to decentralize and move to less expensive communities. The federal highway system also served as the impetus for the decline of the railroad industry.

The CB&Q was Aurora's largest employer until the 1960s. With the construction of the textile mills, gristmills and the railroad shops, Aurora became an industrial town. It began to prosper as early as the mid-1800s. According to some accounts, the community experienced little of the labor strife that often stopped commerce in Chicago, and it was also considered more progressive than its nearby neighbors. In 1851, the city opened the first free public school district in Illinois. It also provided a high school for girls, who normally stopped schooling after primary classes. Word of the open and tolerant environment spread, and it soon drew a variety of immigrants, as well as former slaves from the southern states.

Beyond Aurora, the CB&Q was massive. By 1900, the rail system employed 35,640 people and included nearly eight thousand miles of western track. As in Aurora, it helped spawn town development and local economies along its routes. The railroad opened tourism to Yellowstone, Glacier Park and other scenic sites. In 1934, it introduced the revolutionary, stainless steel Zephyr passenger trains to open a new era of diesel-powered rail travel. Eighty-five years had passed since they laid the first spike. The original line was for a small wood-burning locomotive that pulled a few wooden cargo and passenger cars a mere twelve miles over track laid with scrap rail.

Like the original construction, the CB&Q roundhouse restoration was done in phases. During a walk through the building, you can see many historical details, like the limestone foundation and the cast-iron trusses and purlins (horizontal roof beams that support the rafters). The truss roof was added in the late 1800s, and portions of the old porcelain knob electrical system remain. In the courtyard, there are remnants of the old tracks that once carried the engines and cars through the bays. New brick pavers honor former rail workers.

The brewpub is located in the newest section of the building, constructed in 1864. The brewery attempted to honor the rail heritage of the Pullman porter when it named their porter beer My Name Is George. According to the old owner of the complex, the National Association for the Advancement of Colored People (NAACP) requested that the beer be renamed. The porters were indeed often called "boy" or "George" after George Pullman. He was the man who brought luxury to rail travel and who hired them. Rail patrons saw the porters not as employed individuals but as servants of George Pullman—and referring to a black man by his boss's name was akin to calling a slave by his master's name. It was synonymous with being called "nigger." America's Brewpub, associated with Walter Payton (an African American) had unknowingly given its darkest beer a moniker that insulted an entire group of black men.

The men who worked as Pullman porters accepted a post-slavery life of servitude and hard work. Often away from their family for weeks at a time, they were required to cover eleven thousand miles or work four hundred hours to earn a full month's pay. It was a grueling schedule filled with unpleasantries and demands, but their sacrifice helped to create the black middle class. Only a generation or two removed from slavery, it was a well-respected job within the African American community. The porters' offspring were not ashamed of the shoe shining, the bed preparation and the toilet cleaning. Rather, they considered the hard work of their forebears as inspirational. These porters are in the lineage of many of today's black professional class, and it was also a job held by many who aspired to higher ranks. The porters can proudly claim Thurgood Marshall, the first black Supreme Court justice; Roy Wilkins, former director of the NAACP; and Benjamin Elijah Mays, former president of historically black Morehouse College in Atlanta. Many more did not attain professional fame, but they worked the rails after earning their professional degrees in medicine, dentistry and law. It was the era of Jim Crow laws; they were educated but they were not equal. So they worked the rails for tips and wages, saving until they could start their practices to serve the black community.

The first porter came aboard in 1867. But with the Pullman records destroyed in the Great Chicago Fire, the identity of this man is a mystery. He was most certainly a freed slave, as George Pullman recognized that these men were perfect for the job. Reared for servitude, they possessed the submissiveness needed to meet his demands of high service and low wages. But they did it because it was a good job that could afford their families the opportunity of decent housing and education. By today's standards, George

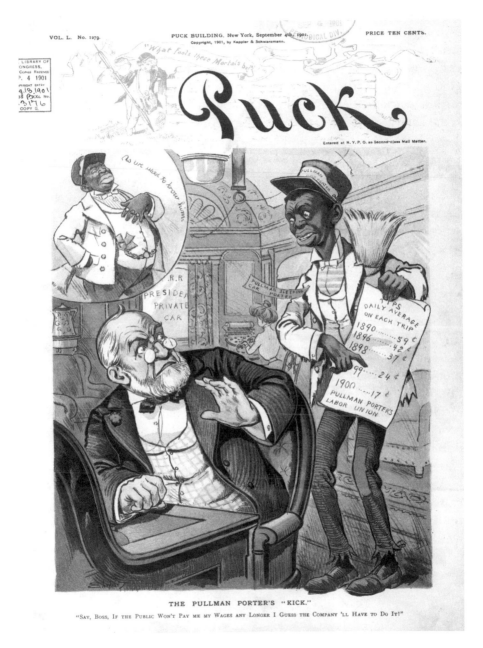

A 1901 newsletter depicting the financial challenges of the Pullman porters. Their treatment, rejection by other unions and decrease in tips led them to organize their own labor union to fight for better wages. *Library of Congress.*

Pullman demoralized these workers. But in the context of the post–Civil War era, he could be viewed as a reformer. He hired blacks for domestic work when most would only hire English or Swedish servants. He sold rail tickets to blacks in the Deep South despite outcry from white passengers. And while he made money off the backs of his workers, he left $5,000 to Arthur A. Wells, the trusted porter assigned to his private sleeping car. This is the equivalent of $130,000 in today's economy.

By 1920, twelve thousand black porters worked the rails, keeping white passengers happy and satisfied. Among the best-traveled citizens in our country, they were black men in a racially charged time and regularly found themselves in hostile territory. To insulate themselves, they formed clubs in the major cities where they could safely congregate and have access to clean sleeping quarters. Excluded from whites-only labor unions, they formed their own.

By 1935, the union known as the Brotherhood of Sleeping Car Porters was so highly respected that it became the first black union chartered by the American Federation of Labor. Not only did it fight for better work conditions, but it also fought to have the name "George" removed as a moniker. It was so pervasive that passengers carried it off the sleeping cars and into restaurants and other service industries. Across the country, black men in service jobs were merely called "George." The Pullman Company, not previously known to support workers' rights, did take uncharacteristic action this time. It began inserting the porter's name card on each car, an action that personalized the men who served the passengers. As for the porter, the brewery changed the name—but not before it had already been entered into the 2006 World Beer Cup, the pinnacle of beer competitions.

As the new owners make changes, some of the recent history will be erased with the renovations and upgrades. But the story of the CB&Q and the Pullman porters is a poignant reminder of a bygone era that remains worth telling.

TWO BROTHERS TAP HOUSE AND BREWING COMPANY

Warrenville, Illinois

THE BREWERY

The Two Brothers Brewing Company was started in 1996 by, once again, two brothers: Jim and Jason Ebel. Tours of the forty-thousand-square-foot brewing facility are offered. In 2008, it opened the Tap House, which serves seasonal and organic American pub fare for customers to enjoy with its regular lineup and specialty beers.

THE BAR STOOL STORY

The railways that preceded the highway system were significant, and not just in transporting people and goods from one place to another; they also spawned the development of new towns across the nation. Warrenville, the home of Two Brothers Brewing Company, is one of these places.

In 1833, the Warren family traveled two miles from Naperville to establish a homestead and lumber business. Bypassed by the railroads for several decades, the community grew slowly. But in 1902, it became a stop along the Chicago, Aurora and Elgin Interurban Railway. Chicago was booming with industrial development, and city dwellers were drowning in pollution. The railroads provided access to the countryside, and as a new stop, Warrenville was still quiet and peaceful. Now convenient to the city, the town prospered and quickly became a popular vacation retreat area for Chicago families wanting to escape squalor and unsanitary conditions.

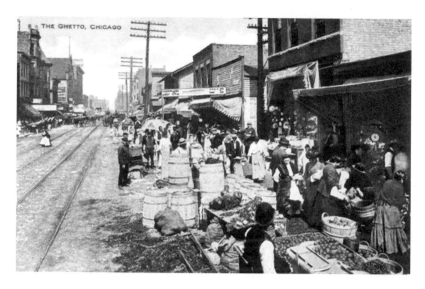

A postcard showing the street market in Chicago's ghetto, a term that referred to ethnic, working-class neighborhoods before it was associated with racial segregation and the underclass.

Social reformers of the day believed that recreational space improved living conditions, and they argued that improved health would increase the output of the city's workers. Although the economic vitality of the region rested on the shoulders of the working class, few of the industrial elites were willing to invest their employees' well-being. Aaron Montgomery Ward, the mail-order magnate, was one of the few who went along with the reformers in advocating for working-class health. In his day, Chicago's lakefront was not a natural resource providing recreational escape for city dwellers. Rather, it was filthy and filled with unsightly squatters' shacks, railroad tracks, service buildings and debris. Believing in his vision for open green space and water access, he spent his own wealth and risked professional relationships to wage a fervent twenty-year battle for the protected, unobstructed Chicago lakefront that exists today. Five years after his 1913 death, his company employed thousands and built a vacation home in Warrenville for its employees.

When the railway arrived in Warrenville, it was also an era of great urban visionaries confronting the need to bring order out of chaos. The Chicago region had grown so large so rapidly that very little thought had been given to design. Among these visionaries were Daniel Burnham and Jens Jensen. Burnham is best known as the preeminent architect who directed the design and construction of the 1893 Chicago World's Fair, as well as for

his plans for Chicago. He envisioned Chicago as a "Paris on the prairie" and volunteered to lay out the first comprehensive plan for controlled growth of any American city. Started in 1906 and published in 1909, the Plan of Chicago remains one of the preeminent urban planning works. Although much of the vision is driven by upper-class bias rather than realities of the working class, it included the goal that every citizen should be within walking distance of a park.

Burnham did not work independently of the civic leaders and business elites. And his pro bono work was not entirely altruistic. After a Special Park Commission report ranked Chicago thirty-second among cities according to park acreage per resident, Burnham's firm was hired to design several new parks and field houses. But while Burnham's name is attached to so much of Chicago, other visionaries affected the city's landscape as well. Among the lesser known and heralded is Jens Jensen, an immigrant from Denmark. While Burnham was helping shape the Chicago of the future, Jensen played a significant role in the city's pre–World War I renaissance.

Upon arrival to his new home in the mid-1880s, he took a job as a laborer for the West Park Commission. Having served in the Prussian army, where he spent three years sketching German parks, his talents led to quick promotion. His first project was the design and planting of an exotic garden—it didn't survive long in the Midwestern climate. Using the railway to travel to the surrounding prairie, he began collecting and transplanting native plants to the urban parks. Through these trips, he also became a champion of the region's ecology, which was disappearing quickly as the city's environs rapidly expanded outward. Rising through the ranks, and in spite of refusal to participate in political graft, Jensen was appointed general superintendent of the entire West Park system of Chicago in 1905.

Jensen held a core conviction that people needed contact with nature because of its renewing and civilizing powers. But the city that Jensen knew was overcrowded with deplorable housing conditions for the poor and working class. In the slums of the Near West and Near Northwest sides, population density averaged one hundred per acre—some blocks even exceeded four hundred people per acre. The parks for which Jensen was responsible were places of refuge. Rather than just providing open space, he used his talent to bring natural environments to those who could not escape to the countryside. By redesigning the parks in the "prairie style," he created natural spaces with meandering pathways. Unfortunately, many of his designs were so natural that they weren't protected and disappeared as a result of neglect. But the Garfield Park Conservatory, which opened in 1908,

Garfield Park's conservatory shortly after it was constructed. Today, an effort is underway to repair the structure after massive damage sustained during a 2010 hailstorm.

remains. Covering 4.5 acres, Jensen created one of the largest enclosed, publicly owned gardens in the world. It was severely damaged during a June 30, 2011 hailstorm.

Jensen's work was supported by other reformers, such as Jane Addams, who founded Hull House and dedicated her life to improving the living conditions of the poor. Jensen passionately held to his conviction that fresh air and quietude was for everyone, not just the privileged few. But despite the argument for parks in Burnham's Plan of Chicago, many of the city's rich industrialists thought him a radical. Jensen believed the industrialists to be harming the poor as much as they were harming nature—and he stated such. An uncompromising but shrewd man, he leveraged these same connections to organize and lobby the elite for ecological conservation. He fought for giant forest preserves that would eventually ring the city with green space, and he helped protect the Indiana Dunes.

Jensen's philosophical conflict created a contradictory career for him, as he eventually worked directly for many of these industrialists. In 1920, he started his own landscape architecture practice and went on to do projects for the likes of Henry Ford, Charles Wacker (a Chicago brewer), Edward G. Uihlein (vice-president, Schlitz Brewing) and Frederick Pabst. Much of his private work is associated with properties now listed on the National

Register of Historic Places, including the May Theilgaard Watts Home in Highland Park.

Watts was born to Danish immigrants on Chicago's North Side in 1893. It was the same year of the Burnham-designed Columbian Exposition—the seminal event during which Chicago showcased its urban, economic strength. Upon reaching adulthood, Watts initially went to work as a teacher in a one-room schoolhouse in a small town outside of the city. But during summers, she studied botany and ecology at the University of Chicago, and like Jensen, she would become an activist for connecting people with the natural environment. In fact, she and Jensen's careers would eventually intersect when they joined forces to encourage growing suburban communities to save wild prairie spaces before they disappeared. When the Morton Arboretum in Lisle was founded in 1922, she was hired as a naturalist, and she worked there until her retirement in 1961. Along the way, she authored several books for studying and interpreting the landscape. Her true legacy emerged on September 25, 1963, when she wrote a letter that spearheaded the campaign for the development of the Illinois Prairie Path. Passing within half a mile of the brewery, Two Brothers honors the work of this woman with its beer, Prairie Path.

During the decades that Watts worked at the Morton Arboretum, transportation methods underwent drastic changes. The cross-country highway system was built, and with post–World War II prosperity, automobiles became affordable. Along with the interstates and automobile ownership came the construction of suburban working-class and middle-class communities. Families were flocking to the newer suburban housing and to better standards of living. As they escaped the deteriorating conditions of America's cities, they were replaced by southern blacks migrating to the northern cities to escape the Jim Crow laws and to find industrial jobs. Northern discrimination and low-income status forced them to take up residence in the declining housing stock of the inner city. Whites who wanted to remain in the city soon took flight. The lines in Chicago were drawn harshly, and to this day it remains one of the most segregated cities in the United States.

These same forces led to the decline of the railroads. People were insulated in their private vehicles and experienced more independence in travel. The highways and invention of refrigerated trucks allowed commerce to be moved more efficiently. By 1959, the Chicago, Aurora and Elgin Interurban Railway had discontinued both passenger and freight services; the lines were abandoned altogether in 1961. The now dormant tracks and garbage littered the once pristine prairies. While many

An elderly woman rides a bike. In the 1890s, the women's movement was intertwined with the bicycle. The bike led to more relaxed attire and provided women with more freedom, both of which were met with resistance. *Library of Congress.*

developers saw land for building and parking lots, Watts saw opportunity for reconnecting people with nature—and the rails-to-trails movement was born. With her impassioned letter to the editor of the *Chicago Tribune*, she inspired a volunteer movement and sparked a national trend.

It would take several years to turn the sixty-one miles of abandoned railway into a bike- and pedestrian-friendly path. Fortunately, the Welfare Council of Metropolitan Chicago established the Openlands Project in 1963—the same years of Watts's infamous letter. With a mission to seek preservation and development of recreation and conservation resources, the Openlands Project played a key role in carrying a vision to reality. Nearly fifty years later, Prairie Path (along with other rails-to-trails projects) is almost taken for granted by many who use it. As the first U.S. rails-to-trails conversion project, it stretches through three counties and links residential areas, business districts, rural spaces and forest preserves. Ironically, disappearing native flora continued to thrive along the railway. Cyclists using the path to visit Two Brothers Brewing Company can pass through some of the last remaining sections of prairie, in existence only because the rail beds were left alone while the bulldozers of suburban development destroyed the natural environment around them.

Although Jens Jensen disliked straight paths, he likely would have approved of the transformation of abandoned industry to reconnect people to nature. Plus, for those cyclists visiting the brewery, the straightness of Prairie Path makes it a lot easier to navigate after enjoying a few brews.

Appendix

PLANNING YOUR BREWERY VISITS

When traveling to the breweries, it is recommended that you check directions before departure or use GPS. If you are using the CTA system, schedules and a trip planning tool are available at http://www.transitchicago.com.

If you are using the Metra train system, the most current schedules and station alerts are available at http://metrarail.com. Points to know if traveling on Metra: always check the train schedule, as some stations are not serviced by each train traveling on that line; to avoid the on-train convenience surcharge, always purchase your tickets before boarding the train (if it is an attended station); Metra sells unlimited weekend passes for seven dollars (at other times, fares are based on zone); and alcohol consumption is permitted on the train, but unruly behavior is not tolerated and can result in being removed from the train before you reach your destination.

Argus Brewery (production brewery with tasting room)
11314 South Front Avenue
Chicago, IL 60628
773-941-4050
www.argusbrewery.com

Call to schedule a tour or visit. With good planning, it is possible to tour the Pullman Historic District and Museum in conjunction with a brewery visit (www.pullman-museum.org).

GETTING THERE BY CAR. The brewery is located on the South Side of Chicago. If traveling from the Loop, take I-94 to Exit 66A (111th Street). Turn left on South Cottage Grove Avenue and then right onto 113th Street. The first left is South Front Street (just west of the railroad tracks). Free parking is available on the street.

GETTING THERE BY PUBLIC TRANSIT. The Metra Electric District line will take you within easy walking distance of the brewery. From downtown Chicago, the line originates at Millennium Station, and you have the options of two stops (Kensington/115th Street or Pullman/111th Street). Refer to the train schedule before scheduling your visit.

Crown Brewing
211 South East Street
Crown Point, IN 46307
219-663-4545
http://crownbrewing.com
Open daily; call or check website for hours.

When planning your trip, consider visiting other points of interest. You should call ahead and check the individual websites: Old Sheriff's House and Jail (www.lakenetnwi.net/member/oldsheriffshouse), Lake County Historical Museum (www.crownpoint.net/museum.htm) and the John Dillinger Museum, in Hammond, Indiana (www.dillingermuseum.com).

GETTING THERE BY CAR. Crown Point is about thirty miles from Chicago, but plan for at least one hour of travel due to traffic. Take I-80 East to I-65 South, Exit 249/109th Avenue Travel on 109th, which will become East North Street. Turn left on North East Street and travel south to the brewery. Street parking is free and plentiful.

Flossmoor Station Restaurant and Brewery
1035 Sterling Avenue
Flossmoor, IL 60422
708-957-2739
http://flossmoorstation.com
Open daily; call or check website for hours. Tour information is on the website.

GETTING THERE BY CAR. Take I-90/94 to I-57 (toward Memphis). Exit 346/ West 167th to IL-50 Cicero and then merge onto 167th Street. Turn left on Cicero and travel for 3.2 miles. Turn left on Flossmoor and travel for 2.8 miles. Take a left on Sterling, and you will see the brewery on the right. Street parking is easy but time limited.

GETTING THERE BY PUBLIC TRANSIT. The Metra Electric District line will take you directly to the brewery. From downtown Chicago, the line originates at Millennium Station, and you will debark at Flossmoor. Refer to the train schedule before scheduling your visit.

Goose Island Brew Pubs
1800 North Clybourn Avenue
Chicago, IL
312-915-0071
www.gooseisland.com
Open daily; call or check website for hours. Tour information is on the website.

GETTING THERE BY CAR. The brewpub is on North Clybourn Avenue, just north of North Avenue. If coming from the Expressway, exit at North Avenue. Head east to Sheffield and then turn left. Turn left at Willow Street, and the brewery is on your right at the next intersection (Marcey Street). There is free street parking and a free parking lot.

GETTING THERE BY PUBLIC TRANSIT. Two CTA lines will get you within walking distance: Red Line—North and Clybourn, walk 0.5 miles northwest on Clybourn and the brewery is on the left; Brown Line—Armitage, walk 0.3 miles south on Sheffield to Clybourn and cross Clybourn to Willow Street, with the brewery being on the right.

3535 N. Clark Street
Chicago, IL 60657
773-832-9040
www.gooseisland.com
Open daily; call or check website for hours. This location does not offer tours.

APPENDIX

NEARBY POINTS OF INTEREST. Wrigley Field (Addison and Clark)—daily tours are offered but note Cubs game days and times if you don't want to get stuck in the crowds. http://chicago.cubs.mlb.com/chc/ballpark/index.jsp; Graceland Cemetery (4001 North Clark Street)—gates open from 8:00 a.m. to 4:30 p.m. Check website for rules and tour information. www.gracelandcemetery.com.

GETTING THERE BY CAR. Goose Island's website provides detailed directions for getting there from a variety of routes. Due to parking challenges and expense, a taxi is recommended.

GETTING THERE BY PUBLIC TRANSIT. Red Line—Addison station, walk west to Clark Street and then south on Clark, the brewery being on the left; Clark Street Bus #22 (twenty-two hours)—there is a bus stop near the front door.

Half Acre (production brewery with on-site sales)
4257 North Lincoln Avenue
Chicago, IL 60618
773-248-4038
http://www.halfacrebeer.com
Tours offered on Saturdays. Tour information is on the website, as well as an extensive list of where its beers are served.

GETTING THERE BY CAR. Lincoln Avenue is a major North Side Chicago thoroughfare. There are a variety of routes, but it is easy to find. They are located between the major east–west streets of Irving Park and Montrose. Street parking is limited but not too bad.

GETTING THERE BY PUBLIC TRANSIT. The nearest el station is the Brown Line—Montrose station; it's a five- to ten-minute walk west and then a few blocks south on Lincoln. Several bus lines will get you within easy distance.

Hamburger Mary's Bar and Grille
5400 North Clark Street
Chicago, IL 60640
773-784-6969
www.hamburgermarys.com

Open daily; call or check website for hours. The brewery section is small, and it does not offer tours.

GETTING THERE BY CAR. Clark Street is a major North Side Chicago thoroughfare. There are a variety of routes, but it is easy to find. It is located between the major east–west streets of Foster and Bryn Mawr. Metered street parking can be challenging on the weekends because of the popularity of the neighborhood.

GETTING THERE BY PUBLIC TRANSIT. Red Line—Berwyn station, walk ten minutes west and then north on Clark; Clark Street Bus #22 (twenty-four hours)—there is a bus stop near the front door; Foster (#92) and Damen (#50) will get you within easy distance.

Haymarket Pub and Brewery
737 West Randolph Street
Chicago, IL 60661
312-638-0700
www.haymarketbrewing.com
Open daily; call or check website for hours. This location does not offer regular tours.

GETTING THERE BY CAR. Haymarket is located at the corner of Randolph and Halsted in the West Loop, just off the interstate. Metered parking can usually be found, but it is pricey. Chicago visitors staying in the downtown area are best taking a cab or walking if the hour is not too late.

GETTING THERE BY PUBLIC TRANSIT. Because of its central location, there are several options. CTA Halsted Street Bus (#8) stops near the door. Concerning nearby points of interest, the area has a few pieces of public art, including the Haymarket sculpture.

GETTING THERE BY METRA. Both Ogilvie and Union Station are within walking distance, but the walk back to the station after dark can be desolate.

Limestone Brewing
12337 South Route 59
Plainfield, IL 60585
815-577-1900
http://limestonebrewingcompany.com
Open daily; call or check website for hours.

When planning your trip, consider visiting other points of interest. You should call ahead and check the individual websites of Plainfield Historic and Naper Settlement.

GETTING THERE BY CAR. It's about forty miles southwest of Chicago, so plan for at least one hour of travel. Take I-90/94 East to I-55 South via Exit 53 toward St. Louis. Travel on I-55 for about thirty-two miles. Exit 261 to merge onto IL-126W/West Main Street. Turn right on Essington Road and then left on West 127th/Regan Boulevard. Follow 127th for two miles and turn right on IL-59. The brewery is in a shopping center with substantial parking.

Metropolitan Brewing (production brewery without tasting room or on-site sales)
5121 North Ravenswood Avenue (at Winona)
Chicago, IL 60640
www.metrobrewing.com
Tours offered a few times each month. Check website for details about the tour, its beers and a link to maps featuring places that carry its beers.

Directions are not provided because it is a production brewery that cannot handle a stream of people just stopping by. It's a small brewery with a small staff. Again, please refer to the website to reserve a tour spot and enjoy its beer at a local establishment or pick some up to enjoy with your chapter at home. And as far as brewery websites go, Metropolitan's is one that is worth a visit.

Mickey Finn's Brewery
412 North Milwaukee
Libertyville, IL 60048
847-362-6688
http://mickeyfinnsbrewery.com
Open daily; call or check website for hours.

GETTING THERE BY CAR. Libertyville is about forty miles north of Chicago's Loop, so plan for an hour of travel without traffic. Take I-94 North toward Milwaukee (portions are toll). Exit IL-176/Rockland Road and keep right at the fork to follow IL-176 West/East Park Avenue for a few miles. Turn right on IL-21/North Milwaukee Avenue. The brewery is on the right. Libertyville has ample street parking, as well as public parking lots.

GETTING THERE BY METRA. The Milwaukee District North Line will take you to downtown Libertyville. The brewery sits across the street from the historic town square, only a few blocks walk from the train station.

The Onion Pub and Brewery
22221 Pepper Road
Lake Barrington, IL 60010
847-381-7308
http://onionpub.com
Open Tuesday through Sunday; call or check website for hours.

GETTING THERE BY CAR. Lake Barrington is about forty-five miles north of Chicago's Loop, so plan for at least an hour and fifteen minutes of travel without traffic. Take I-90 West (portions are toll). Exit Roselle Road and follow ramp toward Palatine/Little City. Merge onto North Roselle Road for four miles. Turn right on Baldwin Road and then take a left on West Northwest Highway/US-14 West. Travel about seven miles and then turn right onto Pepper Road.

Piece Brewery and Pizzeria
1927 West North Avenue
Chicago, IL 60622
773-772-4422
www.piecechicago.com

GETTING THERE BY CAR. Goose Island's website provides detailed directions for getting there from a variety of routes. Due to parking challenges and expense, a taxi is recommended.

GETTING THERE BY PUBLIC TRANSIT. CTA Blue Line (O'Hare)—Damen Station, walk north to North Avenue and then turn right, the brewery being only a few minutes from the station and on the right side of the street; CTA Damen Bus #50—exit Damen and Milwaukee/North Avenue, and it is a one-minute walk east; CTA North Bus #72—exit Wolcott, the brewery being nearby.

Two Brothers Brewing Company and Tap House
30W315 Calumet Avenue
Warrenville, IL 60555
630-393-2337
www.twobrosbrew.com
www.twobrotherstaphouse.com
Tours offered on Saturdays and the Tap House is open seven days a week. Check website for details and hours.

GETTING THERE BY CAR. The brewery and tap house is located thirty miles west of Chicago. Take I-90/94 East and merge onto I-290 West. Then take I-88 (tolls) and exit Route 59 and head north. At the second stoplight, turn left on Butterfield and go one block to Barkley Road. Turn right and then take the first left onto Youghall. The next road is Talbot. Turn right and then go one block to Calumet. Turn right. The brewery is on the southeast corner of Calumet and Talbot.

GETTING THERE BY METRA. Metra does not serve Warrenville; however, bikers may wish to travel by Metra to a nearby station. Ride west on the Prairie Path; this will get you near the brewery than travel by road.

Two Brothers Roundhouse
205 North Broadway
Aurora, IL 60505
630-264-2739
www.twobrothersroundhouse.com

GETTING THERE BY CAR. The brewery is about forty miles west of Chicago. Take I-90/94 East and merge onto I-290. Take I-88 (tolls) for twenty-two miles. Exit IL-31 toward Aurora/Batavia. Turn right onto South

Lincolnway/IL-31. Travel for about a mile and a half and turn left onto West Illinois Avenue. Then turn right onto North Broadway/IL-25. The brewpub is less than a mile away on the left. There is ample lot parking.

GETTING THERE BY METRA. Take the BNSF Line (starts from Union Station) to the last station. The train station and brewery are next to each other.

ABOUT THE AUTHOR

The author earned her PhD at the University of New Orleans and now resides in Chicago's Andersonville neighborhood. In addition to a career in public policy and community development, she is a humanities scholar and longtime craft beer enthusiast. Combining her love of great beer and her training as an urban social scientist, she hopes that you will enjoy her pint-sized history lessons along with your pint.

Visit us at
www.historypress.net